My Home As I Remember

NATIVE WOMEN IN THE ARTS

Lee Maracle and Sandra Laronde, Editors

Natural Heritage Books

My Home As I Remember

Published by Natural Heritage/Natural History Inc.
P.O. Box 95 Station O, Toronto, Ontario M4A 2M8

Edited by Lee Maracle, Sandra Laronde
Printed and bound in Canada by Hignell Printing Limited, Winnipeg, Manitoba.
Cover design by Marilyn Mets/Peter Ledwon, Blue Sky Studio, Toronto.
Cover art adapted from *CRUX-I-FICTION* by Teresa Marshall (with permission of the National Aboriginal Achievement Foundation)
Back cover art:
> © Cat Cayuga *A Nation Is...* (video still)
> © Teresa Marshall *CRUX-I-FICTION*
Title page art © Napatchie Pootoogook *Women Today*

Canadian Cataloguing in Publication Data

Maracle, Lee, Editor
> My home as I remember

Includes index.
ISBN 1-896219-53-5

I. Indians of North America-Literary collections. 2. Indian women-Literary collections. 3. Indian art-North America. I. Maracle, Lee, 1950 -
II. Laronde, Sandra, 1965 -

E99.A73M9 1999 700'.82'097 C99-930515-8

Natural Heritage Books acknowledges the support received for its publishing program from the Canada Council Block Grant Program. Also acknowledged is the assistance of the Association for the Export of Canadian Books, Ottawa. Natural Heritage Books acknowledges the support of the Ontario Arts Council for its publishing program.

To all our relations

Contents

Three: Poetry

Five: Short Stories

Preface

The braiding together of Home, Memory and Native Women in this book has such simple and elegant significance. In our memory is housed our history. We are an oral people: history, law, politics, sociology, the self, and our relationship to the world are all contained in our memory. Home is for us origin, the shell of nurturance, our first fire and the harbinger of our relationship to the world. Home is the domain of women. As such it shapes our governance of the way we engage the world and shape our relationship to it.

Many of the Native women in this text began their lives in communities from which they are removed but far from alienated. The original passion, the old feelings and the memory of home are all wound together to reshape the lives we lead now. In our beginnings are the processes which speak to how we do things; they define culture. Some of the remembrances of home find us still searching, still struggling to affirm our origins, to reclaim those original processes which signify our cultural selves. For some, our memory sharpens images of home. For others, the loneliness, the emptiness of home is a tangible thing. For all of us, the memory of home is more than physical, geographical, emotional or even spiritual.

Stone is the foundation of the beginnings of the natural world. From stone springs all of our songs, our aspirations and our dream world. From stone sings out the story of the whole of Turtle Island and our relationships to earth, flora, fauna, sky and star worlds. Home is our first stone; the stone from which humans shape relationship. *My Home as I Remember* embraces our totality in much the same way as stone forms the foundation and sings the song of the natural world's historical beginnings.

Memory is significant. We are who we are by what we remember and what we do not. The perception of home in the pages of this work tell us about how the women in this book see themselves and what shaped the governing principles in their lives.

The women in this book braid our strands of memory of home from the perspective of our origins, and our current womanhood; in the process, we reaffirm cultural origins, explore ourselves and experience rebirth. Each piece forms a wedge in the circle of homes from which we individually rise. In this circle is a composite picture of all that is unique and typical in our homes. Each memory is offered to the reader wrapped in gentle words and presented with tenaciously eloquent candour. Memory takes on life, social significance, feminist governance, sociological future, and then returns to the heart as a beautiful gemstone. We offer each piece, each memory, each moment to you, the reader, that you may understand the fire of our origin and commit us to your memory.

Lee Maracle

Introduction

Home is something that is carried with us everywhere, like the shell of a turtle. Home is at the centre of our lives. It is about people, land, culture, and what we dream. The way in which we remember "home" is crucial. How we dig for forgotten or buried memories of home is equally significant.

On behalf of Native Women in the Arts, I asked the contributors to write about anything on home, anything from an account of childhood, to the meaning of home, the connection of house with body, mind and spirit, the home we have always dreamed of, or whatever *home* conjures up. In *My Home As I Remember*, readers will find recurrent motifs and concerns as expressed in memoir, poetry, fiction, song and visual art. Rooted and uprooted childhoods are recounted, and homes are built, imagined, abandoned, lost or discovered. We are guided to varying landscapes: deep woods, reservations, border towns and bustling urban neighbourhoods. We will hear from different generations of women, who speak from the heart on identity and place at the turn of this century. In this landmark volume, 62 writers and visual artists are represented from nearly 25 nations, including some who are well-known and some who are published for the first time.

Published by Natural Heritage Books in collaboration with Native Women in the Arts, *My Home As I Remember* celebrates the exceptional talents of First Nations, Inuit and Métis women artists. For the first time, Native Women in the Arts also includes indigenous women contributors from New Zealand, Hawai'i and Mexico. In presenting the work of 154 Aboriginal women to date, Native Women in the Arts continues a unique and national role in publishing and promoting Aboriginal women's literature within Canada and throughout other indigenous territories.

I gratefully acknowledge the women writers and visual artists who made this third publication possible, without whom *My Home As I Remember* could not exist. I would also like to extend my gratitude to the many Native women who have gone before us. They have led to our artistic and cultural survival as a people moving into the new millennium.

Sandra Laronde

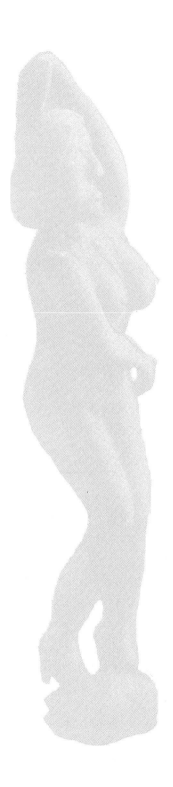

poetry

NATIVE

spirit woman

here i am, nokomis
i am here
walking behind
following
tracking your steps

i hear you, nokomis
softly singing
your voice
dancing on the tips
of the birch trees

once burned into my memory
long before i passed
through the stars
songs to the earth
songs for my heart
reclaiming
my forgotten ways

here i am, nokomis
i am here
spirit woman
touch me
i am
'woman from the south wind'

Sharon L. White

Sharon L. White is a member of the Wolf Clan and the Leech Lake Band of the Ojibwe. She is an artist, writer and poet, musician, businesswoman and community leader. She is the publisher and editor of the *Beaver Tail Journal*, a Native American creative writers' journal. She is also a book illustrator of *When Beaver Was Very Great* which was nominated for Minnesota's State Book Award. She operates Little Bay Arts & Crafts Co-op and designs web pages and commercial art.

Rez Times Three

1) I thrive on mama's warmth
and work
a newborn spider
i sit at her feet
on cool green grass
under the birch trees

she makes
the laws of the universe:
 sundogs speak of cold weather
 toties[1] sing one snow and spring is born
'that's what the old Indians know,' she says
and the old Indian
aunties make soup down the road
grammas tell stories in the next house
uncles split wood in the bush behind our house
grampas turn soil south of the sugar maples
every direction, door & window
leads to a woman
who knows my great-grandfather
to a man who carries babies
the oldest sacred stories

hands
holding the threads
of the universe
together

2) i know the difference between
 me & straight women
 but mother's twisted rigid thoughts
 set leghold traps
 to crack my bones
 good-intentioned relatives
 hope to skin me
 tan my hide
 sew my smoked
 skin to their feet
 as moccasins to be worn
 at a marriage ceremony

 i refuse to dance
 instead i leave a piece of flesh behind
 just so i can walk away

3) fifteen years later
 the silence of the bush
 (broken only by the rattle of leaves
 and dry crow wings flapping)
 rises from my pores and says
 we're still here if you come back

 i can't

 i want nothing more than to rest
 my feet
 on your dark soil
 or hear the stories
 of my auntie's death
 and the many births

 while i lie
 in bed listening to the city's hum
 poplar trees'
 luminescent leaves
 and glistening bark
 call to me

i remember their ashes
make the best corn soup
 i am hungry

 always hungry

i think i hear
that sound like rain
hitting the sidewalk:
snow snakes [2] travelling slick
and quick on hard packed snow
and i turn my head
expecting to see
polished wood flying
down the street

nothing

nobody reaches for me like the rolling hills
nobody misses me like the wide, slow river
nothing calls me like the silence

1 Toties is pronounced DOE-dees and translates as young frogs.

2 Snow snakes, polished poles about six feet long, are thrown down, a track of snow.

Susan Beaver

I am an out and proud Mohawk lesbian from Six Nations of the Grand River Reserve.
I recently completed my studies in Creative Writing at the En'owkin International
School of Writing. My work appears in *The Colour of Resistance* and *A Piece of My Heart:
An Anthology of Lesbians of Colour*. I've also published in the *Rebel Girls' Rag* and
Fireweed Feminist Quarterly in Toronto.

Poetry as Ceremony

This quintessential Spirit: voices often penetrate our spoiled, scarred psyches and force thoughts to materialize, expressing themselves in creative forms: song, dance, music, art, literature. These creations provide us with a sense of interconnection, a sense of being. They give us proof of what we all seem to crave the most: love and hope.

Ceremony, a necessary act to obtain or regain balance with the earth, replenishes her love for humankind. The purpose of ceremony is to integrate: to unite one with all of humankind as well as the realm of the ancestors, to blend one with all of creation.

I have found a deepening connection to the land through experiencing poetry. The land where my ancestors lived and died for thousands of years. The land fed with the skin, bones, and flesh of those who have gone before me. The same land that now feeds me, and waits for me to return the favour. It is a way to reunite with the voices of the old ones, to carry out their desires and prayers concerning ourselves and this earth, and to wake us up from our dreamless sleepwalking.

The History of Our Mothers' Dreams

The deepest part of ourselves
is formed before we are born.
This is when the grandparents
breathe into the dreams of our mothers.

Heavy breaths coloured by
yellow black red and white.
Sighing breaths sounding of
poetry singing music and dance.

Falling breaths formed from
birds clouds trees and tears.
Yet we do not know
the history of our mothers' dreams.

The coloured sounding forming dreams
holding the breaths of our grandparents.
It is time we begin
to listen.

MariJo Moore

MariJo Moore, of Cherokee descent, is an author/artist/poet/journalist. She is the author of *Returning To The Homeland - Cherokee Poetry and Short Stories, Crow Quotes, Tree Quotes, Stars Are Birds and Other Writings*, and *Spirit Voices of Bones*. MariJo was honoured with the prestigious award of North Carolina's Distinguished Woman of the Year in the Arts in 1998, and nominated as Writer of the Year in Poetry by the Wordcraft Circle of Native American Writers and Storytellers in 1997 and 1998.

MariJo resides in the mountains of western North Carolina, where she writes a weekly editorial on American Indian issues for the *Asheville Citizen-Times*. She is also editing a first time anthology of writings by North Carolina American Indians entitled *Feeding The Ancient Fires*. She is the owner of rENEGADE pLANETS pUBLISHING which publishes the work of North Carolina American Indians.

Really Delicious Fry Bread

To make really delicious fry bread
you need to start the night before
with some long slow sweet sweet
loving with the precious one of your choice
This brings good dreams of swimming in cool water
Listen to birds singing alive the dawn
Then put on some strong Indian music
Half of the taste, the part that makes her rise
is the joy you stir in
but you start with plain old white flour
1 cup to 1 teaspoon of baking powder
& a sprinkle of sugar
This makes enough for 2 if you have
bacon, potatoes & eggs
If it's all you have
better make 3 cups worth
Sift everything a couple of times
Pour in your water in a spiral
the way the earth moves
It helps if you're singing with your pow wow tape
or laughing with your lover
Stir until you get a good dough
not too sticky
Knead in all the names who need a prayer
Shape her into a round mound
& cross her in the four directions
with a sharp knife
Cover with a clean red bandanna
& make the coffee
When you've finished your prayers
she'll be ready to cook up
The oil should be hot enough
to make your spit sputter
but not smoking
Pinch off a piece of dough & roll her
around to make a patty

pulling her flat with your fingers
Some people put a hole in the middle
for the spirits to pass through
& some roll them out on a board
but I do it the lazy squaw way
While you're frying them don't get caught
up in writing a poem
or talking on the phone
because even the crows
won't eat them burnt
We love fry bread in memory of the women
who, thrown off their land
with death in every dawn
& starvation in their children's eyes
made this food
so we'd all survive
Each tender bite honours our ancestors
who despite the greatest genocide
in world history
kept on
& kept on
so we could share bannock this morning
and love

For Burning Cloud and Falcon

Autumn Compost

My pitchfork turns over memory old meals
bouquets of first flowers
children left scattered unnamed
in Germany Texas Okinawa
seeds of my father my youngest brother
both of them part of the military
which issues condoms
but not respect for women
the enemy
I can't reach these weeds of my blood
Silences where they grow
are longer than my 50 seasons
The rest of us have toiled in domestic service
usually for the rich
cooking pruning cleaning typing smiling
dreary with a kindness germinated in fear
Digging l need to ask these men living in my tree
if they have raped
afraid of their answers whether lie or truth
I've stared at their betrayals
wounded sucked up honey of women abandoned
until only bitter hives are left
I speak to their survivors
with a caution bred of arid years with my mother
whose dreams and joy died as
she grew large with me
I was born early
after 36 agonizing hours of labour
she may still hold against me
Saved by the frost of glass houses called incubators
created originally to keep alive gangrenous limbs
made by the war which devoured my father's soul
I still seek someone who will
nurture me as carefully as I turn my fork letting
in light air germs who make this soil
while I listen to small brown birds
who sing as though sorrow
is yesterday's kind rain

bringing fresh green sprouts
& fat pink worms

For Kathe McKnight

Chrystos

Chrystos is Menominee from the San Francisco area. She is self-educated and an activist for numerous Native Rights & Prisoners' causes. She is the author of *Not Vanishing, Dream On, In Her I Am, Fugitive Colors* and *Fire Power*. Her writing is also widely anthologized. Chrystos is the winner of numerous awards such as the National Endowment for the Arts Fellowship for Literature, Audre Lorde International Poetry Competition and the Sappho Award for Distinction.

Drive Your Own Damn Canoe

I can remember my grams telling everyone
"drive your own damn canoe"
when relatives or neighbours would start
talking about someone from our community.
I could always picture her words in my mind
"These people, trying to drive every one
else's canoe, but their own."
I can remember my grams' words, telling
Ole Auntie not to talk so much about people
and their problems. She told Ole Auntie
"You're not their umpire, so get the hell out of
the big leagues, and go braid sweetgrass."
I could always picture her words in my mind
Ole Auntie with an umpire mask on playing
ball with the big guys.
I can remember my grams telling Aunt Ester
"Go wash your mouth out with soap, and
grow up, stop your complaining. The
Creator can hear you."
And I could picture Aunt Ester with a bar of
homemade soap sticking out of her mouth
and the Creator's ear listening to her
moaning and groaning.
I can always remember grams telling us how
rabbits live life and travel.
"They're like humans in a way. The Creator
gave us the same journey, so remember
what you start you have to finish, and
especially, what goes around comes
around."
I could picture the rabbits running round in a
circle, jumping and chasing each other on
the path. I could picture the rabbits running
faster and faster only to run in a circle past
themselves in the end.
I can remember grams' words, "Pray each

day and offer tobacco, this shows you respect
what the Creator gave to us."
"What's that grams, what did the Creator
give to us?"
And she would answer with the question,
"What are you giving back?"
I could picture my life
my spirit, mind and body, but I am still
trying to search for the gift to give back.
I've travelled, had children, worked many
jobs and created music. But, my gift for the
words which my grams gave to me
is keeping me busy, trying to find peace
and life's harmony.
Thanks, grams, for your words, I drive my own
canoe.

Charlotte Kayenderes Green
"She Understands What She Sees"

My professional objective is to preserve the oral teachings of the Native Elders. In a
respectful manner, I hope to bring together the old and new without the loss of
identity. I also make original Corn Husk dolls, and I have had eight professional
shows. I am Mohawk Tyendinaga from Deseronto, Ontario.

home

Red path
black road
 red earth
 black smoke,

2 ravens floating in
a dead sea

1 salmon perched on
a scorched tree,

 red smoke
 black earth.

breath in,

 Aztlan on my mind

breath out,

 jaguar shed
 my skin

breath in,

 butterflies raise
 my soul

breath out,

 Grandmother,
 welcome
 home.

The Open Veins of Aztlan

Grandmother,
welcome

to this tomb
We call home.

Come in,
let me pour
you a cup
of blood

 let us drink together.

last night
the vultures ate my brothers
and left only the veins
that choked my mother the moon
into day

Grandmother,
can you heal
with your medicines
this gaping wound?

 Sing me a song
 Tell me a story,

 make me forget,

Never!

this dream

 this dream
 We call home.

Deborah Ramos

I am a Mexican/Chicana (Mexica Nation) from El Paso, Texas, Aztlan. I am 23 years old and a junior at the University of Minnesota where I am pursuing my individual studies in American Indian Studies, Chicano Studies and Studio Arts. I am especially focusing on Chicana and Indigenous Women's contemporary arts and literature.

writing brings healing close

they say I have exilda's chin
which in itself is a blessing
her mouth her nose her chin her hands
my mouth my nose my chin my hands
my hands are long and slender
piano hands is what they say

one time I wrote a test to see what I should be. my score was good, the woman said.
look, she said. look here at this mark on the page, that's your music mark. see? it goes
right off the page. this is unusual for a woman, did you know? usually it's only men
who score this high in music.

I am confused by this woman's talk. what test of music? there was no music on the
test.

ah, yes, she says, it's in the test. it's comprehension. you're a musical genius, did you
know? why, look at those hands. do you play piano? you should, you know.

but these are not piano hands
piano hands are made in large houses
this is history
piano hands are for the moneyholders
hoarders
 of the gifts

my mouth my nose my chin my hands
my hands are mother hands
my hands are lover hands
my hands have learned to listen
my hands have learned to write

my granny used to tell me that if I'm going to speak, especially in public or in writing,
I should be careful that what I say is true to my spirit. you have exilda's rainbow
mouth, she'd say. you are lucky. that mouth of yours will bring you power. each gener-
ation is here for the next, ma petite, to be the ground for the children to walk on,
layer after layer after layer.

my mouth my nose my chin my hands
my mouth is mother mouth
my mouth is lover mouth
my mouth has learned to listen
my mouth has learned to write

that's about when my nose stopped growing. at twelve. before then, my nose was relatively gross. gross as in large. my father's nose was very large. my father picked his nose. ate from it too. me too sometimes it's true.

only the nose knows, my granny used to say. she'd say, smell that air, ma petite, smell that water, our mother earth is being raped and plundered by and for the privileged and the privileged are still sitting around picking their noses and feeling greedy or powerless or guilty or something and wondering what to do about it. I don't know, she'd say. it seems like so many people want to feel oppressed or something. it seems like so many people want to blame someone(s) for their situation(s), whether privileged or powerless. you have the nose, ma sweet. that nose of yours will learn to smell for people's words, tones, faces, bodies, spirits.

my mouth my nose my chin my hands
my nose is mother nose
my nose is lover nose
my nose has learned to listen
my nose has learned to write

my chin juts out a bit, which is I think why my mouth looks upside down. lots of times when people talk to me, they look at my chin. it has little black and silver hairs that pop out here and there. I've heard my chin is friendly, manly, rich and full of life.

I'm lying on the shore by the river
the water's up this year
my head's upstream
I lift my chin and feel
river passes over me
river presses into me
I'm river
I'm me
my great great granny, exilda dufort-dubois dit lafrance. her mouth her nose her chin

her hands. guide me. teach me. tell me. that writing brings healing close, ma petite, that writing brings healing close.

Sharron Proulx-Turner

I'm a Métis and a two-spirited mom of two. In my thirties, I went to university and received a Bachelor of Arts and a Master's degree in English Literature. I now teach university English at Old Sun College, Siksika Nation, Alberta. I live, love, write and play in and around Calgary, Alberta.

He mana ʻo i hūnā ʻia

In a house
behind a house
a steel lattice hides the sea
the shadow of the sea
the smell of medicine bottles
in rooms locked
the man's eyes, the grey sea
covered
locked in the steel smell of the sea
fingers like salt
children like rust
vinegar and ink
combed through the man's tongue
wired on his wrist
teeth crumbled in enamel basins
sprinkled into eyes
fly buzzing between knees
bees buzzing in rafters
toes crushed by shoes
stuck to milky floors
mouth netted by words
nostrils scaled
hooked
hung to wire
tongue wired to words
stung by salt
fish dragging chains through teeth, eyes
hooked to the steel lattice.

Heritage

Mahina speaking is steam rising through the Puna rainforest.

They stood the girl at the edge of the pool filled with green clouds and reflections of dead war heroes, and said, "Jump!" Seaweed caught her hair and pulled her to the bottom. She bit the weed and chewed as her breath rose around her like small moons. When only one moon remained, she swallowed the last branch, opened her mouth, and blew the moon into the sky.

Mahina speaking is kamapua'a biting hairs of wet hāpu'u.

When it rained, the girl walked errands barefoot in Chinatown, jumping over buildings mirrored in the sidewalk. Filipino men mouthed her from the barbershop beside the shop where her Popo sold homemade palaka shirts and rubber boots. Once her feet slipped through the reflection. She climbed out wearing a pair of her grandmother's boots and kicked the muddy teeth of the men. Their canines pierced her soles and stuck in the bottom of her feet, drawing blood. She shook off the boots, and ran away splashing in her new heels.

Mahina speaking is the sea's tongue licking foam, coral, and broken trees.

Dad refused to go to his in-laws, who told Hawai'ian jokes in Chinese behind his back. The jokes were a feather cape the girl stole when her father wasn't looking. It made her invisible to the family. The bigger she grew, the bigger the cape grew until her mother threw it into a tub of hot water. It shrunk to the size of a doll. Drinking the steamy water, the girl's limbs contracted into her torso, her belly hardened into a seed, and her head shriveled to a nipple. Wearing only skin, she flew towards a light in the forest.

Mahina speaking is a wall of bamboo cracking before a flood.

As he tested the knot, older brother said: They torture POWs by tying them down on a bed of sprouting bamboo. Every day the growing shoots pushed deeper into her belly. When she was fifteen, the girl pulled herself loose, swallowed the stand of bamboo, and grew into a circle of sandalwood. The woodcutters came to cut her down, but she dripped sap into their eyes, slashed their throats with the tip of her lowest branch, and dabbed the sweet blood into her hollows.

Mahina speaking is the swell of Kīlauea's rib before it snaps open.

With her father's machete, the girl hacked at her roots. But the blade's rusty teeth bit her, licked her bleeding lips, and jumped into the river. The roots grew around her body like a ball and pushed her upstream, where a spring bled between rocks. She chewed through the roots, and crawled backward into the hole. Ferns grew around her lips, moss covered her teeth, hau encircled her tongue.

Mahina speaking is rain pelting the basins of the moon.

Roots split the garden wall, like veins on a woman's temple before she screams.

D. Mahealani Dudoit

I am a Hawai'ian woman born and raised in Pāwa'a near Waikīkī on the island of O'ahu. Two sounds characterize my memories of childhood: the incessant pounding of pile drivers in the dirt lot next door and the wind through the fronds of the coconut trees outside my window. Even as a child I sensed the meaning of those pile drivers and, as soon as I was old enough, I took flight with the wind. But after many years in the world, I returned home and to the beginning of a new kind of journey home for me. Our mo'ī Kauikeaouli once said, "Ua mau ke ea o ka 'āina i ka pono," the sovereignty of the land lies in spiritual integrity. That is the struggle of Hawai'i today.

Good Stories

One night dad kicked mom
left a gash in her leg,
she didn't make a sound
just looked up in surprise
I was in my room
trying to think about good things
my sisters cried and screamed
I ran from my room
I didn't see the kick
but I saw the blood pour
from her leg thru her jeans.
We left that night as he slept
went to my auntie's house.
My mom drove – I never asked
if her leg still hurt.
She and auntie talked all night
I lay on the floor and listened
to them whisper,
my mom about my dad
my auntie 'bout her man
Mom said she would leave him
Auntie said she would leave Sam
I remembered hearing that before.
I guess I fell asleep
Tho' my belly felt like something
was biting from inside
and I couldn't find a story
to make my dreams real good.
We woke early and got dressed
in yesterday's clothes
and grabbed our lunch and books
Mom dropped us off at school.
my friends gave knowing looks.
My teacher asked
why my homework wasn't done
and I sat there in my silence

making up good stories
and played them in my head.

Dawn Dumont

I am a member of the Okanese Cree First Nation located in southern Saskatchewan. I am currently completing my Masters degree at the University of Toronto's Faculty of Law.

Kitchen Voices

I.

In the crowded rooms of childhood
listening.
Your voices
the familiar lullaby
punctuating the world
from one door away.
Hobby horse dreams
waltzing to the tones of meaning
behind the muffled words.
Hearing Hank Snow crooning
beneath the kitchen clatter
and sizzle of midnight hamburgers.
Tennessee Ernie Ford singing background
for your version
of "The Old Rugged Cross."
Sounds
lapping against the shore
of my knowing
of my sleep.

Evenings spent eavesdropping
on pickle jars popping
as they cool and seal,
Santa's mad wrapping frenzy
on Christmas Eve.
The play by play
of Cassius Clay
and Sonny Liston
mingles with beer bottles
and late night laughter.
Sometimes wires cross
and Saturday night fights
start in the kitchen.
Your voices crashing
heedless angry waves

wear themselves out
and stumble off to bed.
In the sudden dark uneasy silence
counting heartbeats.
Then growls and pops of snoring
join the night howl
of the freight train.
The sunflower farmers'
staged gunshots
bark in the distance.
These moving tides of sound
bearing me through the years.

Every slumber woven with vibrations.
Chair legs scraping the floor,
Ice cubes cracked from their trays,
Tips tinkling together
coins counted and dropped
into the giant Seagram's bottle bank.
Shadows cross
the narrow stream of light
beneath the door of my room
or my dream,
popcorn scents
puff through the keyhole.
Twin aches,
comfort and loss,
wake me again.
Torn between rising
to the night kitchen,
or letting the spell
of unreality
lull me like water...
Water running from the faucet
your day's stories flowing out
sometimes flooding the space between you.
Wanting despite everything
to hear it forever.

II.

In my childhood's bedroom
beside my own deep-dreaming baby
resting together in one hollow
of the age-worn mattress.
Listening again – and still.
Floors creak beneath your tired step
Cupboard doors pop open snap closed
Grocery sacks crack along their folds
And you sit shuffling cards between you.
Mingled with these
sound pictures
carry from other rooms and years.
My breath always coming and going
with the motion of your voices rising
and whispering themselves away.
Waiting now,
child rustling the bed beside me,
humming soothing his Morphean visions
careful never to disturb my own.
Twin dreams with only a door between them.
One spun of longing of need
for old voices to speak on and on
to ferry me across time on their currents.
Fearing your life song will fall silent
and with it the pendulum of meaning.
Too quiet nights will stop my ears
my speech, my joy.

Puffs of child warm breath on my arm
trace like voices the buried vein patterns
born of blood and devotion
from the bed hollow of sound and history.
Softly here I try my voice
cooing the story of years
years shaped by the wash
of womb, sounds breaking against sleep.
Rest, baby, in this room made of memories

Still now, my heartsounds patter against yours.
Listening, again, as from a distance
certain I am the voice of his slumber
knowing truly it is my cadence and range
that sings to this child a known world.
And that it is but a simple translation
of those ageless kitchen voices
chanting lives
chanting from the far side of my soul
sha sha sha shaaa
and follow me.

III.

In the locked house of memory
old spirits rise, sing rockabye.
Rounded vowels soften our sleep
oohing like pine wind
sweeping through our dreams
stardusting us with longing.
Lingering traces hibernate
in soundless sleep,
until whining cicada summers
toss us awake
hot sweating
waiting for footsteps
for thunder drumming.
Twilight, starlight, moonlight, midnight,
dusky hours of deep dark.
Nap, nod, drowse,
sink to soft rest and surface
always to the subtle base
background rhythm of kitchen nightlife.
January moon's
too bright light
crackles along winter air
with sharp undercurrents of sound.
Static, sulfur smell of a match
just scratched awake,

splat of a fly swatter,
a cough, a sneeze
one final yawning,
Sweet dreams,
and turn out the light.
In these muted echoes of night
is formed our daylight.

Kimberly Blaeser

Kimberly Blaeser is an enrolled member of the Minnesota Chippewa Tribe, and grew up on the White Earth Reservation in Northwestern Minnesota. Currently an Associate Professor of English at the University of Wisconsin-Milwaukee, she teaches courses in Native American Literature, Creative Writing, and American Nature Writing. Blaesar's publications include a critical study *Gerald Vizenor: Writing in the Oral Tradition* and a book of poetry *Trailing You* which won the 1993 First Book Award from the Native Writer's Circle of the Americas. Her poetry, short fiction, personal essays, and scholarly articles have been anthologized in over fifty Canadian and American collections. She is the editor of *Stories Migrating Home*, a gathering of Anishinabe prose. She is currently completing a second book of poems, tentatively entitled *Absentee Indians*.

She Spends Her Time Thoughtfully Weaving Beads Onto A Loom

blue, black, red, orange and yellow,
these beads contain
no sparkle
she pinches them from bags to her plate

sharp, straight and ready
needle's eye is difficult
to thread
her fingers shake... slightly

cedar, solid and dependable
loom is woven with thread
so strong
51 spaces wait for these beads

blue, blue, blue, blue, blue, blue
black, black, red, red
orange, orange, yellow, yellow
more blue...

on the thread 51 beads dance
to meet each other
to form a string
yet... a row alone makes nothing

gently... gently...
these beads
are introduced to 51 spaces

needle drives through these beads once more
giving purpose
providing life

these beads begin to form a picture

A sharp, brilliant arrow
pointing
towards
her.

April E. Lindala

April Lindala, a member of the Six Nations Band of Delaware/Mohawk, lives in
Upper Michigan and works in Public Broadcasting at Northern Michigan University.
She dedicates much of her free time to a variety of expressions of Native art including
beadwork, singing and dancing. April has also written for the *Native American Student
Newsletter* at Northern Michigan University.

Nindaniss Wawashkeshikwesens
On a Winter Night

In the moonlit quiet of a winter night
as I pass her bedroom door
Nindaniss Wawashkeshikwesens
my daughter the Deer Girl
springs from her bed.
While in startled graceful silence
she totters to my arms,
from the distant dark forest of her sleep
her wide dark eyes ask "What? Wegonen?"
and I carefully lead her back to her bed.
"My girl, sh, sh, niban, niban,
go to sleep, go back to sleep."
Folding her long legs beneath herself
she nestles under the pile of blankets
I tuck around her
and her wide dark eyes close
as she returns to the distant dark forest sleep
of the Wawashkeshiwug.

My Dad, Who Treats Life Like a Sacrament

He drank the whole glass down all at once
 with respect
 eyes closed
 no stopping
And said to me,
"There's nothing like milk, my girl"
and I could see
cows and green grass and sunshine,
beautiful children with white teeth,
all that might be
the good life
it was
a sacrament right there for the taking.

Linda LeGarde Grover

I am an Ojibwe woman enrolled in the Bois Forte Band of the Lake Superior
Chippewa, through the Minnesota Chippewa Tribe. I am married, with three children
and two grandchildren. I believe that one important role of the poet is that of
historian and witness to history. I hope that my poetry can in a small way contribute
to an old and honoured tradition of Ojibwe people, that is, passing our experiences
and our ways on to our children and grandchildren.

Jingle Dress Dance

The Jingle Dress
Symbol for the healing
Spreading the spiritual teachings
Through the dance.

The unique designs
Created from dreams
Moving ever so in the sunlight
Like twinkling stars in the moonlight.

The clans coming alive
And together as one.

The powerful, vivid dream is seen
Consisting of the four grandmothers
And of the four grandfathers
Who come with instructions.

Oh Keeper of the sacred Jingle Dress
Teach in your mother tongue – Ojibwe
While the drum beats on
And the healing continues.

Sharon Syrette

I am an Ojibwe from the Batchewana First Nation (Rankin Reserve) which is located near Sault Ste. Marie, Ontario. I've been working for my community for the past nineteen years as an office receptionist. I'm a mother of three, two boys, James and Eugene, and my girl, Melanie. My life experiences are the inspiration for my poetry. I have now eighty poems in my collection. My dream is to have my collection published in book form.

my granny inspired me

when i was a little girl
with my thick black hair
my skin was brown as wet mud pies under the beaming rays of sun in july
i didn't wear much except for a pair of underwear
i spent most of my time outside

sitting having tea with my granny

all the while all of my cousins were out running around on the reserve i loved visiting
my granny on the reserve, which was only weekends or almost all of the summertime
i was between five and seven i sat beside my granny on the right-hand side of her
favourite chair

and her favourite table in the kitchen she'd tell me stories about my mom when she
was young, about all my uncles and aunties about her life back in wiki and how it was
when she married my grandfather and moved to his reserve, mississauga

in 1917, my granny was married she was only seventeen then she moved to my grand-
pa's reserve nobody liked her because she was odawa:kwe and from wikwemikong,
manitoulin island this did not stop her from trying though she raised seven children
and had the only farm on the reserve

my grandpa died in the sixties i don't know much about him only that he was a good
man and one of my brothers is named after him i still hear stories about him, my
grandma calls him, old Charlie

he made my favourite swing outside my granny's house it's tied up to an old red pine
tree it's still there today and he made my granny's house
my granny's stories were mostly told in odawa, which is very similar to ojibway, they
were about her life: her struggles her good times her hard times her family what she
learned most in this life
and how beautiful life is

she loved life she encouraged me to go out and have an adventure she always knew
how to have a good time no matter what she was doing or where she was one of her
favourite things to do was have people over at her house and have some good beers

after she felt good, i remember my granny pulling out her harmonica and my uncle his guitar and they would play music and sing then my granny would start to dance tap dancing and two steppin' her favourite song was, roll out the barrel:

...roll out the barrel
roll out the barrel of fun
roll out the barrel
we'll have a barrel of fun...

on her ninetieth birthday the reserve had a big birthday party for her she got up and sang roll out the barrel i think that was one of the last times she sang that song

when she smiled her wrinkles were so beautiful and when she laughed her whole body jiggled with delight i can still hear her laughing...

after she died in 1993, i couldn't remember all of this i couldn't speak of her

now i celebrate her life

i celebrate my memories of her
i celebrate her stories she shared with me

i remember her today as i write this she taught me so much about being anish-nawbe:kwe it is her roots that i follow when i write my stories, my poems i connect all memories with her she has inspired me to do what i am doing now following my dreams and now as all of our stories come to me i write for my nephew and nieces...and my unborn child i write for all creation and all the many generations to come

when i want to remember more...
i sit outside and look to the east my home
and dream of that little girl that i once was
sitting beside my granny sipping tea and eating scones
laughing and talking in anishnawbe

Nimkis
(Love Song From Earth)

dusty winds
breathe
through you
capturing
your essence
inhaling your scent
enters my body
like sweet maple sap
sliding down my throat
quenching my hunger

savour all moments
of you, when you
beat down alleys
and valleys
that echo your song
you dance Nimkis
across grey cloudy skies
sparking life
as mountains shake
my spirit
awake

I breathe rain
in big gulps
sprinkles down
lightning dances
in your eyes
rain pours on me
whispers down
my limbs
into my roots
spreading around
your magic

flashing sound
thunder clap
gliding down
glistening bodies
with fresh water
sparked with Nimkis
blue static
shivers down
as hands touch
and calm me down

rain drizzles and
sun winks through
strained clouds
you walk through
skies, proud like
a rainbow dancer
sticking around
for a little while
this time to dance
with me
deep down
in my roots.

Vera Wabegijig

Vera, from the Bear Clan of the Odawa/Ojibwe nations, is twenty-four years old. She recently graduated from En'Owkin International School of Writing and is continuing her studies at the University of Victoria. Vera recently received the William Armstrong Literary Award.

A Dream

I was told to lift
My bowl of food
And to look at the sun
Then, to feed the people.

Melvina Watts

I am a freelance writer and artist from the Wabigoon Lake First Nation. I have a twelve-year-old daughter, Debbie, and she is a great teacher. I have been on the wellness path for fourteen years.

Mother Earth Speaks

I had sat and listened as Mother Earth Spoke,
her words were soft and sweet to hear.

I heard her words saying to me,

My child, hear and learn for I have lived
since the beginning of time.

I have laughed with the wind,
smiled with the sun, and
cried alongside the great creator.

My child, I need you to understand what life is all about.
I need you to know that for each seed that is planted,
no matter whether it be man or creature, plant or idea,

That seed has a journey, it is to grow, and learn,
see and dream,
walk and believe.

My child, each seed is a life and
its journey needs to be kept
safe and sound,

So that one day another seed will be created
and able to travel its own journey.

My words to you mean only one thing
take care of what is around you and
enjoy each spirit as they walk their path,
as you walk yours.

Tina Goerz

Tina Goerz lives in Edmonton, Alberta. "I was adopted out of my community and am presently on a journey to discover my roots. I have been writing poetry since I was fifteen years old. My poems have been published in a magazine *Living our Losses* and my poems are used on notes, cards and prints."

"I would like to dedicate my work to everyone in my family, my friends who have seen the real me, and especially to my good friend Cindy who has always encouraged me to write."

My Precious Baby

When I wake you always seem to be there,
moving inside me,
I know it is you inside there.
I am forever wondering if you are a girl or boy,
No matter what sex you are I'll still love you very much,
I already got you your first toy.
I'm just waiting for the first day we meet,
I can't wait to hold you in my arms,
and to see your little hands and feet.
Two more months I have to wait,
and every day seems to be so long,
I'm counting down the days to your due date.
Finally when a day has gone by,
it is time to go to sleep,
Here on my bed I lie.
Still you seem to be there,
moving inside me,
It is you my precious baby, inside there.

Pearl Rose Greene

My name is Pearl Rose Greene. I'm Anishnawbe from Shoal Lake First Nation No. 40. I was born in Winnipeg, Manitoba on August 29, 1976, but was mostly raised on the reserve. One of my main goals is to write my own book of poetry.

Celebrating Corn

Pounding the pestle
against a white stone
she grinds last year's harvest to meal.

I have planted my corn

A thin white-gold powder
clings to her hands;
around her, air shimmers.

I have planted my corn

One of the puppies is barking;
staccato yap yap
punctuating her strokes.

Let it grow tall and beautiful

Beside her, an aunt stitches
shell beads to deerskin, as young women
lean toward clay pots to stir embers.

washed by sunlight

The men are out gathering
new clay for ochre. Beyond domed
bark houses, fields

watered by rains

stretch small earthen mounds toward the river.
Redbuds blossom, their branches upturned like hands
to receive the sky's sacraments.

corn and squash, blessed by waters

She pats meal into ashcakes. Already
night falls as a smell of bread rises.
Painted, the men drum their song.

Grandmother, we plant our seeds

For a thousand years now,
for a thousand years after, her people
dance when redbuds bloom
celebrating corn.

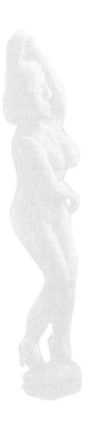

Karenne Wood

Karenne is an enrolled member of the Monacan Nation, and she works for the tribe, writing grants and conducting historical research. She has studied at George Mason University and the University of Virginia. Her poems have appeared in numerous publications in the U.S. and Canada, including *The American Indian Culture and Research Journal, The American Indian Quarterly, Gatherings IX, News from Indian Country,* and *Red Ink.* She is a member of the Wordcraft Circle, and she lives in Virginia with her partner and their four children.

artworks

April White - *Killer Whale*

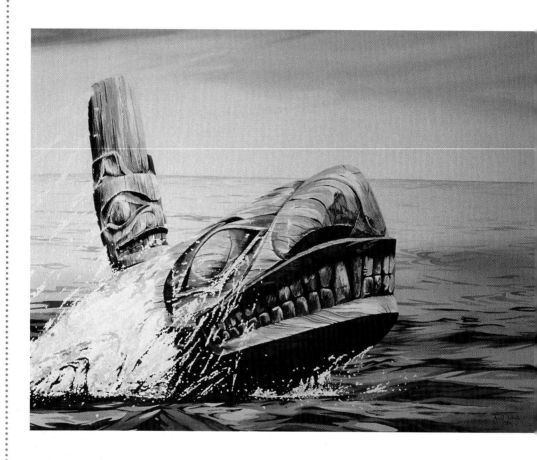

Oviloo Tunnillie - *Woman On High Heels*

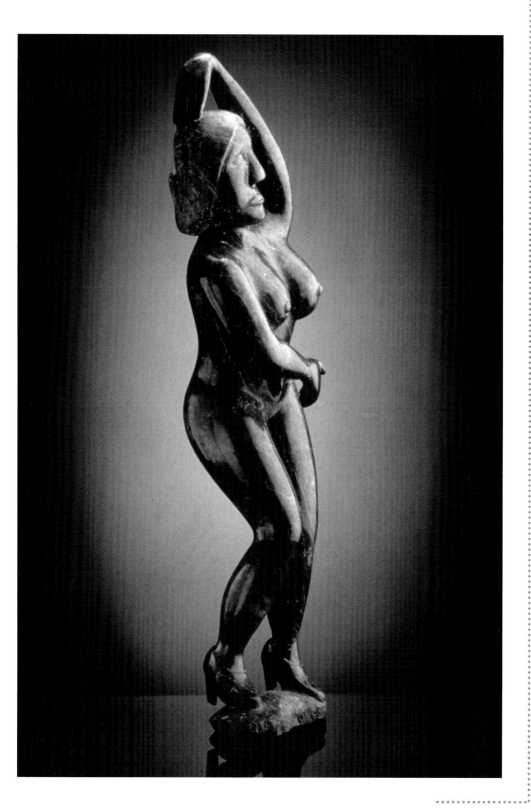

Teresa Marshall - *CRUX•I•FICTION*

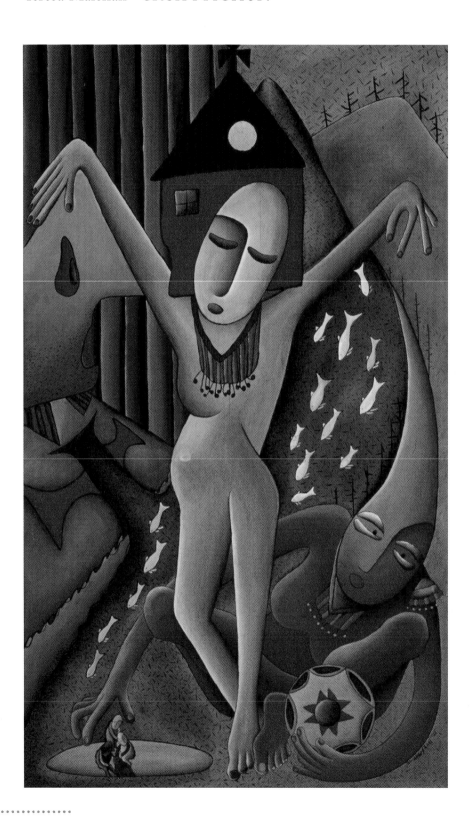

Napatchie Pootoogook - *Women Today*

Mary Pudlat - *Safe Haven*

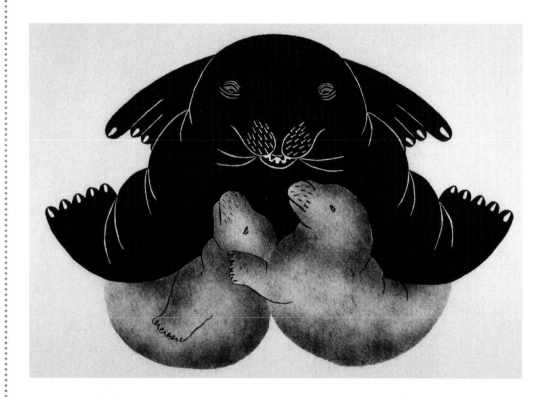

Melanie Printup Hope - *Heron*

Mauricia de la Torre Garcia - *La Mujer Chamana (The Shaman Woman)*

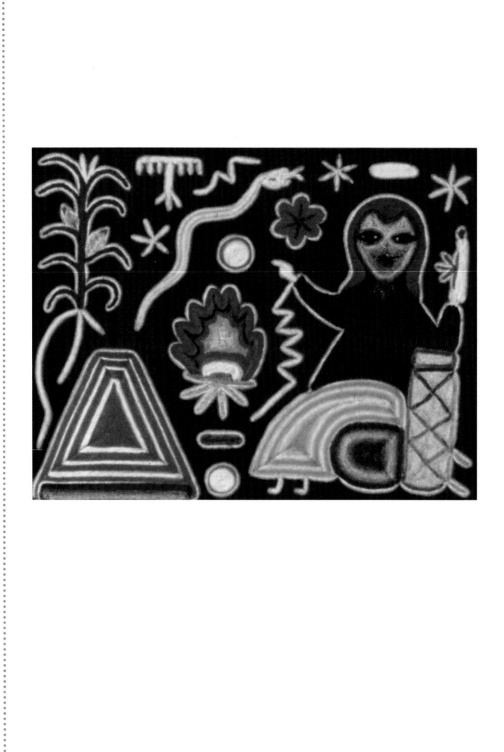

Dozay (Arlene Christmas) - *Untitled*

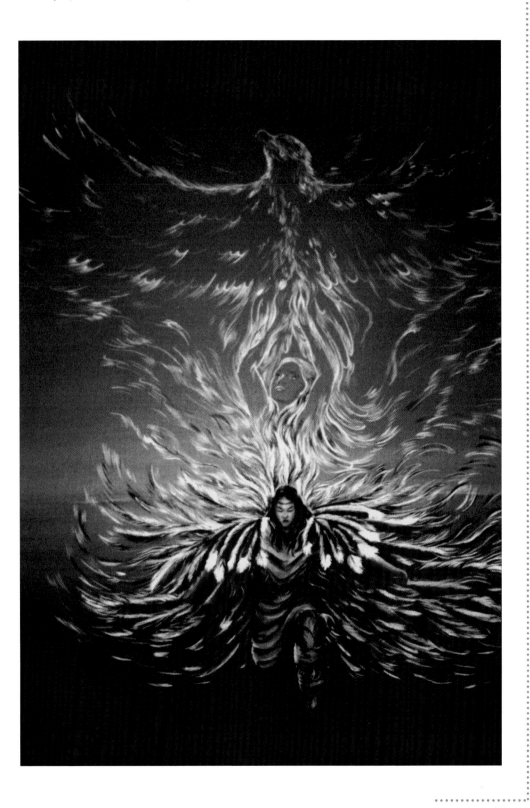

Cat Cayuga - *A Nation Is...* (video still)

Artists

April White

April was born on Haida Gwaii, the Queen Charlotte Islands, to the Massett Band of the Haida, and she is Raven Clan. Through her father, she is a direct descendent of the renowned Haida artist, Charles Edenshaw. April knew that eventually art would become the focus of her life, but also that education was essential to acquiring experience and perspective.

April received her Bachelor of Science degree in geology from the University of British Columbia. She has worked as a geologist in remote areas of the Canadian west, an experience which has been of assistance in developing the visual faculty essential to her painting. Entirely self-taught, April's natural inclination to paint stems from her heritage, and is rooted in a tradition in which art was a part of everyday life.

Oviloo Tunnillie

Oviloo comes from a very artistic family in the community of Cape Dorset. Her parents Toonoo and Sheojuke were artists, as are her brother Koperqualuk and her sister Napatchie. Some of her exhibitions include: "Our Land Transforming: Celebrating the Enduring Spirit of the Inuit," "Baffin Island Sculpture Exhibition" and "Fantasy and Stylization – Cape Dorset Sculpture."

Teresa Marshall

Teresa is an urban Mi'kmaq living in occupied Canada. She was raised on both a red Indian and white military reservation which, as symbolized by the national flag, makes her truly Canadian. Living between both worlds has necessitated an intense critical exploration of her dual identities which she explores through writing, art making, theatre and research. Teresa has exhibited her work nationally and internationally in both solo and group shows.

Napatchie Pootoogook

Born at Sako, a traditional camp off the coast of Baffin Island, Napatchie is the only surviving daughter of one of the most important Inuit artists, Pitseolak Ashoona. Napatchie belongs to a family with a strong artistic identity that has contributed signficantly to the reputation of Cape Dorset art. Like her mother, Napatchie began drawing

in the late 1950's. Since 1960, her work has been included in almost every annual collection of Cape Dorset prints.

Although much of her early work reflects Inuit beliefs in the spirit world, the main thrust of her prints and drawings since the mid-70's has been more concerned with recording traditional life, clothing, and local Inuit history. In prints such as "Atchealda's Battle", "The First Policeman I Saw", "Nascopie Reef", and "Whaler's Exchange", Napatchie uses a vigorous, energetic figurative style to bring to life significant events of the past.

Mary Pudlat

A prolific Canadian Inuit artist, Mary Pudlat retains clear memories of her early years living a traditional Inuit hunting lifestyle in Arctic Quebec. Orphaned as a teenager, she lived with her brother before moving to Baffin Island. There she married Samuelie Pudlat in 1943 and continued to live in traditional semi-nomadic camps along the south shore of Baffin Island until they moved permanently to Cape Dorset in 1963.

She began to explore her own talent for sculpting in soapstone and for drawing. Mary turned to her experience on the land for inspiration, carving and drawing birds, fish, human figures, and activities from her culture. The demands of her young family left her limited time for her art in the years that followed. With her children becoming more independent, Mary returned to drawing in the 1980s.

Melanie Printup Hope

Melanie is of Tuscarora descent and was raised on the Tuscarora Indian Reservation in western New York State. She earned her Bachelor of Fine Arts degree in graphic design at the Rochester Institute of Technology and her Master of Fine Arts degree in electronic arts at Rensselaer Polytechnic Institute. She lives in Schenectady, New York where she owns her own graphic design business. She is currently an assistant professor in graphic design at The Sage Colleges, Albany, New York. Her video and installation work has been shown throughout Canada and the U.S. Melanie has recently received a Rockefeller Foundation Intercultural Film/Video/Multimedia Fellowship, and has received additional fellowships from the New York Foundation for the Arts, The National Endowment for the Arts, The Rockefeller Foundation, The Andy Warhol Foundation for the Visual Arts and The Jerome Foundation.

"My work is an exploration of my Native American identity and ancestry. As an artist, I conveyed my own personal experiences of cultural and spiritual growth through the use of drawing, traditional beadwork, sculpture, computer-generated images, animation, digitized sound, video and installation."

Mauricia de la Torre Garcia

Mauricia is Huichol and learned the traditional art of her people by studying with her father Ramon de la Torre Lopez, who is a master artist. She was born on September 22, 1980 in Southern Baja California in Mexico, and now resides in Vivero, Cuatro Plantas, at the top of the mountains in La Sierra Madre Occidental.

Mauricia began studying with her father at the age of ten. She now works in his school called Siete Rayos or Seven Lightnings as a junior artist. In a workshop in Cuatro Plantas, Mauricia teaches technique and symbology to apprentice artists through the reproduction of original works of art as taught to her by her father.

Dozay (Arlene Nicholas Christmas)

Dozay was born and raised on the banks of the St. John and Tobique Rivers in New Brunswick. She left the Tobique Reserve at the age of 18 to pursue her education and interest in art. She worked as a trainee with the New Brunswick Museum and later moved to Nova Scotia and enrolled at the Nova Scotia College of Art and Design in Halifax.

Cat Cayuga

Cat is Onondaga/Mohawk and has an extensive multidisciplinary background spanning 14 years in the cultural, artistic and social sectors. Cat is an independent videographer with two works currently in distribution, *A Nation Is...*, and *Do You Hear Me Scream* which has received international recognition.

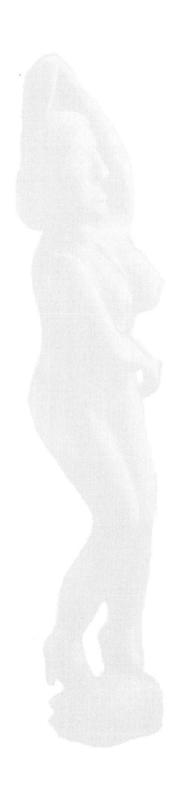

poetry

Like the Trails of Ndakinna

We're French and Indian like the war
my father said
they fought together
against the English
and although that's true enough
it's still a lie
French and Indian
still fighting in my blood

The Jesuit who travelled up the St. Lawrence
found the people there uncivilized
they will not beat their children
he wrote in his diary by candlelight
and the men listen too much
to their wives

You who taught me to see no borders
to know the northeast as one land
never heard the word Ndakinna
but translated without knowing it
our country, Abenaki country.

Grandmothers and grandfathers
are roaming in my blood
walking the land of my body
like the trails of Ndakinna
from shore to forest
They are walking restlessly
chased by blue eyes and white skin
surviving underground
invisibility their best defense
Grandmothers, grandfathers,
your blood runs thin in me
I catch sight of you
sideways in a mirror
the lines of nose and chin
startle me, then sink
behind the enemy's colours

You are walking the trails
that declare this body
Abenaki land
and like the dream man
you are speaking my true name
Ndakinna

Earth Medicine for an Abenaki Woman Landsick in L.A.

for Carol Snow Moon

Sister, I send you these pebbles
from the mouth of the Dawn Sea,
and the snow that swirled around us
on the beach in York as we gathered them,
and the voices of the gulls as we walked
the furthest reach of the tide. I send you
storms, a northeast wind, and waves
that toss you in the arms of passion.
Sister, this is a bed of desire I send you,
an ungentle lover who howls outside
your door day and night, who embraces you
with song deep as a growl, who
stings you with winter kisses
that make you feel your own heat.
Sister, this is how we know who
we are. We are alive. Taste
the salt of home.

Trees

- for my father, Paul J. Savageau, Sr.

You taught me the land so well
that all through my childhood
I never saw the highway,
the truckstops, lumberyards,
the asphalt works,
but instead saw the hills,
the trees, the ponds on the south end
of Quinsigamond that twined
through the tangled underbrush
where old cars rusted back to earth
and rubber tires made homes for fish.

Driving down the dirt road home,
it was the trees you saw first,
all New England a forest.
I have seen you get out of a car,
breathe in the sky, the green
of summer maples, listen for the talk
of birds and squirrels, the murmur
of earthworms beneath your feet.
When you looked toward the house,
you had to shift focus,
as if it were something
difficult to see.

Trees filled the yard
until Ma complained,
where is the sun.
Now you are gone,
she is cutting them down
to fill the front with azaleas
The white birch you loved,
we love. Its daughters
are filling the back.
Your grandchildren play

among them. We have taught them
as you taught us, to leave
the peeling bark, to lean
their cheeks against
the powdery white and hear
the heartbeat of the tree
Sacred, beautiful, companion.

Cheryl Savageau

Cheryl is of Abenaki and French-Canadian heritage. Her second book of poetry, *Dirt Road Home*, was a finalist for the 1996 Paterson Prize, and was nominated for a Pulitzer Prize. Savageau has received Fellowships in Poetry from the National Endowment for the Arts and the Massachusetts Artists Foundation. Her poetry has been anthologized in *Durable Breath, Through the Kitchen Window, Returning the Gift, Poetry Like Bread, An Ear to the Ground,* and *Two Worlds Walking.* She has also received a Writer of the Year Award from Wordcraft Circle of Native Writers & Storytellers for her children's book, *Muskrat Will Be Swimming,* and in 1998 received the Wordcraft Circle Mentor of the Year Award.

Kinosewak-Fish

I was told that fish
do not have an identity crisis.
Well, at least I know
I'm not fish.

Sage

The smell of sage clings to me,
reminds me I belong
to the earth.
I do belong.

Learning to Listen

"A woman once described a friend of hers as being such a keen listener that even the trees leaned toward her, as if they were speaking their innermost secrets into her listening ears. Over the years, I've envisioned that woman's silence, a hearing full and open enough that the world told her its stories."-Linda Hogan

I am so eager to listen
to the natural world
woven into the unnatural fabric
that we call a city.
I push myself,
as though I could learn this listening in a day.

I begin to realize
that listening from a deeper place
is an art form,

a skill to be learned,
to be practised daily.

Slowly I begin to hear whispers...
voices of the land,
water,
wind,
plants,
and animals.

Last night the wind gently told me
to let go of feelings
I no longer need to carry.

Today water shared
her joyous laughter with me
as we celebrated a bright winter's day together.

I give thanks to those who have spoken
and allowed me to listen.

Darmody Mumford

Darmody is of mixed Chippewa-Cree and English ancestry. She grew up in Toronto, spending most of her summers with her grandparents in Alberta. She now lives in Calgary and is developing a science curriculum from an Aboriginal perspective.

Chm nihssing Highway

Chm nihssing Highway.
Five kilometres
from island to mainland.
On a good day -
just a five minute drive.

Chm nihssing Highway.
Open to all traffic,
accessible to most vehicles.
Scenic route.
Toll free.

Non local traffic
proceed with caution.
Watch for pedestrians.
snowmobiles, four wheelers,
slow moving vehicles,
fast moving vehicles,
and sliding vehicles,
Beware of
snowstorms,
windstorms,
pressure cracks,
soft spots
or break-up.

In an island community
sometimes a risk
is not a risk at all
but rather a winter way of life.

Grandmother's Dance

When Grandmother
first appeared
she glowed sumac red.

Her reflection
which stretched
across the water towards me
served as a glimmering red gown
at an elegant evening formal.

On cue the waters began to wave roughly –
her reflection swaying lazily –
giving her the appearance of dance –
a soft, proud,
traditional woman's dance.

Before too long
her dance ended.
The red faded
and she stood – protectively
hovering over,
in her place beside the stars.

Grandmother
Weaver of life.
I give thanks

Edna H. King

Edna H. King, an Eagle clan member, is Anishnaabe from Beausoleil First Nation.
Living on Chiminising, Edna is a writer, poet, and artesan. Her work has appeared in
Do Whales Jump At Night (Groundwood Books), the *Colour of Resistance* (Sister Vision
Press); and she has co-authored a children's book called *The Adventure on Thunder Island*
(James Lorimer Publishing). In 1992, her short story "Adventure on Thunder Island"
won the Vicky Metcalf Award for Children's Short Story Writing.

Land Sickness

I'm flung away, flung far from the edges
of ocean, beneath brown, unsettled skies;
I have no salt spray for my hair, no chill
gray sand beneath my feet. I am bereft
of crisp ocean kisses and wild seaweed,
dancing like a sultry lover around my ankles.
Perhaps I will die from land sickness, this
never-ending orphanage from Maine's shore.
Soon they will find my body, petrified and blue
in a corner of the desert, eyes squeezed shut
against fetid breeze and fiery desert sky.
In one tight fist will they find a single drop
of salt, a tear that began in the surf of home.

Abenaki Bones
(a reflection on the failure of King Philip's War, 1868)

Our bones fled north
paddled icy waters, carried
stories and songs to Odanak
across the Ouelle River

Bones from Pennacook
from Norridgwock and Ossipee
from Saco and Kennebec,
bones running through night

Our bones scattered
in bloody fields
in sad forests
far from winter camp

the enemy believed
our bones ruined
put down like corn
burned to meal and ash
Abenaki bones are strong

grow new skin and flesh
live in safety, leaning together
around old stories, in new camps.

We Go Forward

We are still here,
laughing and singing, giving
birth to babies and ideas.

We dance at wedding celebrations
and over invisible borders, our faces
fitting perfectly along the landscape.

Our grandchildren speak words
and tell stories risen from pond
bottoms and tree stumps, thought

to be brackish or cut down. Songs
which rattled around in museums
echo from Passamaquoddy to Penticton.

We are on the front line, healing
in shiny clinics, defending in polished
courtrooms, teaching in universities.

What have we lost on the way?
My grandmother says the better question
has to be "where are we headed?"

Carol Snow Moon Bachofner

Carol Snow Moon Bachofner, Abenaki, is originally from Maine and now resides in California. Carol is a daughter, wife, mother and grandmother, and when she is not writing poetry, she enjoys leading and attending poetry workshops all over Turtle Island. She is a mentor poet in the Wordcraft Circle of Native Writers & Storytellers, and has published a creative writing textbook, *Drink From Your Own Well*. Her poems have appeared in several journals and anthologies including *Gatherings* published by Theytus Books.

It's okay

It's okay to have visions while living on Turtle Island

It's okay
to not have to
work crazily
at a boring job
pays loonies
causes devastating distractions

from really working hard
relearning ancestors' traditions
original languages
sacred teachings
spiritual
cultural
beliefs
values

By the way
this ladder applies to
every day living
the good life

ahhhhhhau [1]

g'chi migwetch [2]

1 The word "ahhhhhhau" was traditionally used by our ancestors. At this time, everyone's opinion on the matter was valued, shared and heard by all. When they gathered for council, they sat around a fire in a circle on Mother Earth. The person seated on the west spoke first followed by the next person seated to the left. This was an opportunity to speak on whatever was in their hearts. After each person spoke, the rest all replied "ahhhhau" in unison. In the end, there was one strong unified voice.

2 G'Chi denotes a special emphasis on greatness or on a much larger scale. Thus, a great or grand thank you. Unlike a casual thank you.

CULTURE

OJIBWE
TONGUE

DISTINCT
VOCABULARY

SAVOURS
DIALECTS

VICINITY
SIMILARITIES

DEFINITELY
SUBLIME

I INHERITED
MUCH

Mary Lou Cecile Debassige

Mary Lou is of Odawa, Pottowatomi, Ojibwe Chippewa and Scottish descent. Born on Birch Island and raised on Manitoulin Island, Ontario, she dedicates these pieces of work to the "Ojibwe Wholistic Law of all Life in the Universe."

Post - Colonial Medicine Stories

It's what happens after being force fed
a colonial diet.

Here I'll trade you some white, the whitest
flour and refined sugar for that moosemeat & maple syrup.
And now seemingly age – immemorial kraft dinner,
libby's beans, pepsi, & klik.

And just watch the diabetes skyrocket.
And just watch the teeth fall out.
And just watch the pounds pile on.
And just watch the people die.
And just watch the people die.

Water Song

Ya wey ya, ya we ya we ya we ya we-we-we weya weya
Ya wey ya, ya we ya we ya we ya we-we-we weya weya

We doke we shen, Manitou Nibi
We doke we shen, Manitou Nibi
We doke we shen, Manitou Nibi
We doke we shen, Manitou Nibi

Ya wey ya, ya we ya we ya we ya we-we-we weya weya
Ya wey ya, ya we ya we ya we ya we-we-we weya weya

We doke we shen, Manitou Nibi
We doke we shen, Manitou Nibi
We doke we shen, Manitou Nibi
We doke we shen, Manitou Nibi

Ya wey ya, ya we ya we ya we ya we-we-we weya weya
Ya wey ya, ya we ya we ya we ya we-we-we weya weya

We doke we shen, Manitou Nibi
We doke we shen, Manitou Nibi
We doke we shen, Manitou Nibi
We doke we shen, Manitou Nibi

Ya wey ya, ya we ya we ya we ya we-we-we weya weya
Ya wey ya, ya we ya we ya we ya, we-we-we weya weya

Michelle Richmond

I was named Black Wolf Standing Strong by an Elder who passed on many years ago. I am Anishnabe, French and a Newfoundlander. I have been inspired by the many amazing women poets of all colours. I would like to dedicate this poem and this song to Jane Ash Poitras, a truly revolutionary artist who has inspired me profoundly.

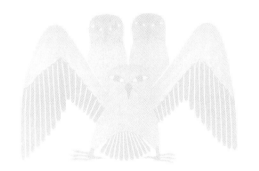

Valley Spirits

i've been present in these hills before
long ago
i know the pillars holding down each valley
they created the shape and form of
these hills
they look on us,
shadows on the brightest days,
are larger than the highest hill they may stand upon
they are there

they were once visible – in the old days
when institutionalized religion did not exist here
when law was known and not written
when we knew to respect our elders
each other and ourselves
before english could ever have commanded these words

now – until we restore their purpose
and regain understanding,
they remain invisible
protecting us
all the while teaching us
so we may mourn them properly

houses have tripped up their paths
cars have made them dizzy
planes have rendered them deaf
but their power remains

we once loved them but today we are confused
we keep silent
we forget

we call them taboo
and are curious in secret.

A Good Friend

down a long dirt road he scurries
fat and huffing
unfocused on his direction
pulling at his stained sleeve
he is oblivious to everything
though he looks around

thick wax build up in his ears
and leftovers from last night's
supper in his teeth
it is now noon
and he is just as pitiful as he
was the day before and the day
before

he often wonders why people
don't respect him
while he blabs away out of line
yes – he even monopolizes
conversation
but he's a writer you see and
once a reporter
now just a big pig
lost in the high overturn
of politics

all he really needs is a friend
or a mother, i'm not sure which
to come by and do his laundry
throw him in the tub
scrub his teeth
give him a new outlook
on life
and a personality

Acts of Violence

i found a wounded
bird today
not the type found
wild in nature,
a domestic bird
it had been used
for company
and one's own enjoyment
for its time, it was
well treated
but when its uses
were spent
the lonely one
made inflictions
upon the bird
causing agony and
open sores
and so, though the bird
overcame
shock and trauma
it soon learned
companions
quick to possess
in future should be
treated with discrimination
as acts of violence
may come by the
gentlest of hands

Lucie Idlout

Lucie Idlout is a poet, organizer, rebel and artist. At seventeen, she was working in Ottawa at the Inuit Tapasarit. At twenty-two, she was managing the HIV, STD and AIDS workshop in Iqaluit. She left that for waitressing and began singing for her own amusement at first, and then increasingly for audiences. She has been writing and performing songs for eight years. One of her most powerful songs to date deals with the issue of suicide, a problem of epidemic proportions in Inuit communities.

"It is hard enough being a musician and trying to survive on your own songwriting anywhere in the world; how about trying to do this as a young Inuit woman living in Iqaluit?"

The Fighter

I sit and watch
the candle in the corner
in the shadows of the wind
untouched...

Cynthia Lickers

Cynthia Lickers is a member of the Six Nations reserve in southern Ontario and is a recent graduate of the Ontario College of Art and Design. Currently she is involved in strengthening a partnership between the Aboriginal Film & Video Art Alliance and V Tape, promoting Aboriginal film and video.

Cradled in Corn

My shadow is long
taller than these seeded cornstalks
tall enough to swallow
the sun
this was our playing place
my sisters
squash and beans
we sang and circled weaving and swaying
hands raised to the sun
now they lie beneath me
still and silent

my shadow is long
cradled in corn
rocking
wrapped and shrouded
in this obsidian shaded shawl
of ancestors
grandparents holding me
cradled in corn
rock-a-bye-baby
in the treetops
screaming crows dive
violently circle me
as I stand swaying
cradled in corn
my voice is theirs
comes in whispers
one wail rising
wind through dried corn stalks
their bones rattling
rusted leaves
dance around me

mixed with dried cornsilk
the hair of the mother
the crows are screaming:
"this earth is puckered and parched

painted with their blood"
there are no tears left

cradled in corn
we planted the seeds
with songs
we made our dolls of
husk and cornsilk
we wrapped our tamales
in its thick coat
our food
our play
our harvest
cradled in corn

my shadow is long
tall enough to swallow the sun
my silent dance partner
we are swaying
rocking
no tears left
I'm waiting for a new
flower
like the sun
to burst forth in flame
then I'll sing
the Green Corn Song

Sandra Abena Songbird – Naylor

Sandra Abena Songbird – Naylor is Abenaki/French/Irish and a member of the Missisquot Abenaki of Swanton, Vermont. Currently, her poetry appears in Unsomo/Redclay, "Moccasin Telegraph" and an anotholgy called *Watch Out! We're Talking*. In 1996, Abena was a recipient of the Mary TallMountain Award for Poetry and Community Service. She can also be seen preforming spoken word and vocals in her band, "The Songbird & The Moor" with musical partner Muhammad Al–Amin. Abena continues to write and perform her "poemsongs" dedicated to Mother Earth and all Earth Keepers.

Calling Me Home

Heartbeats barefoot dance
meets moist clay suck cling
cutting a gentle swathe
through cool green native bush
vehement sweep of furling ferns
winding vines
dense damp layers of vertiginous lines
tattooing the sky
ancient spirits, the mighty kauri
unearth their pungent aroma
smoky punga and roots
darting birdsong flutes split the silvery mist
lush familiarity
my grandfather's cloak
the humming
of ancestral voices
above below and all around me
mellifluous stamping feet
the imprints of generations gone before
security
divinity
affinity
with the land
whenua the land – whenua placenta
whenua the land – whenua placenta
I am tied to my wa kainga umbilically
hear them calling to me
daughter

Spiny layers of coral
baby spines
a miraculous order of uneven lines
flagrantly female
fallopian grooves
like a vulva cupped to my hand
chalk...bones...

...ribs...lung
haunting
skeletal imprints
foetus fossils
markings on a cave wall
earth scrawl
ancient history survives
an aperture of
warm ocean light calls to me
daughter...daughter

Pale soles of brown feet
burning coral sand
the pull tickle of waning tide and
frangipani lime
wash a horizon of blue
the blue of bloodlines
the blue of moko
the blue of age etched in spirals
on wizened black skin
calls to me
daughter...daughter
calling me
home

Jillian Tipene

A writer, performer and director, Jillian's work is deeply rooted in her identity as a Maori woman of Nga Puhi, Te Aupouri and Irish descent. A founding member of SoundBite Poetry Collective, she also writes for arts magazines. Jillian is currently working on her first collection of poetry entitled "Sepia," which is an historical account of four generations of Maori women, her matrilineal whakapapa.

Hope

I remember
horses running
out of the clouds
from the West

I remember
my lover's eyes
softly looking
down on me
like stars

I remember
my ancestors' voices
singing across the Hills

I bring my Pipe
I turn toward the light
rising in the East
my breath, meeting
the line
between life and death

meeting the silent wind of Tunkasila,
mixing with the sunrise.

I Only Dream in Red

I only dream in Red,
past midnight,
I hear drums
and see visions

spirits singing
with me at Sundance

there is no thirst
any longer, only
a mirror of water

parting the line between
this world
and the other

the voice of my grandmother
lifting me on the wind

My People will be as the wind
again, courage is everywhere
Do you hear it in your heartbeat?

It is the strength that covers
mountains.
It is the sound that lasts
forever.

Rosemary White Shield

Rosemary White Shield, writer, teacher and counsellor, lives with her fifteen year old son in St. Paul, Minnesota, where she teaches at the American Indian Magnet School. She is of the Anishnabe Nation, and has been writing since the age of six. Her poetry comes from that discipline of seeing the extraordinary in the ordinary.

Surviving

 The soil is sparse
 The height is dizzying
 The wind blows constantly.
The seed is blown and caught.
The thoughts reel endlessly.

 The soil is sparse
 The height is dizzying
 The wind blows constantly.
I know, I can survive.

 In soil so sparse
 In dizzying heights
 In the wind.
I think, I can survive.

So, growth begins.
The cells divide.
The cells divide.
The tissue differentiates.
The beginning is small.
Because,
 The soil is sparse
 The height is dizzying
 The wind. It blows and blows.

The seasons come
The seasons go. But still
The cells divide.

I hope, I can survive.
 The drive to reproduce
 Is strong, but blunted
 Because,
 The soil is sparse
 The height is dizzying
 The wind just blows too strong.
I hope. I can survive!

Marion W. Macdonald

Marion is a member of Six Nations and lives in Simcoe, Ontario. She is a teacher/librarian employed by the Norfolk Board of Education and works with children between the ages of 5 and 14 years. Marion has two children, Alison and John.

Talisman

Think of something to protect me
 a pelt of silver fur, muscles ripping underneath.
Dancing alone with the lights out,
 a leather jacket for the heart.
Porcupine quills dyed purple,
 the tattoo over my left breast.
A stone in my pocket, worn smooth.

Think of something to ground me
rock not water,
 roots not severed,
 heart tied to itself
tied to the earth not the other
 skin to skin,
what I crave
 to be connected,
 to be apart
 to stand.

Think of something to bring me home.

Kate Berne Miller

Kate Berne Miller is a mixed-blood Eastern Band Cherokee/Irish poet and writer. She has worked as a book buyer at Red & Black Books for the last eight years. She is forty-three years old and will return to school to finish her Bachelor of Arts in creative writing and Native literature. She is working on a manuscript called *House of Birth*. She lives in Washington State with her partner of eleven years and her two dogs.

Clear Vision

I see a place
trees
waving
watching

untold stories of generations
sit folded in their branches
their wisdom honoured
they wait

there's time.

the children,
gifts
so gently nurtured
sing full songs
their knowledge lovingly placed,
simple verses
at the centre of community.

the mothers,
waters
moving freely in their work
lifegivers.

The fathers
recognize life
see beauty
and colour
bursting from rocks
giant swashes
spirit paint
like northern lights
stroking the sky.

love

creeping softly
through small cracks
shines inside
out
the face of mother

earth

smiles

There,
we only see and know
relations

feel all actions

no Other
us
them
that those

but
all my relations

past
present
future

this understanding,
massaged into relationships

Kim Anderson

Kim Anderson is a Cree/Métis, raised in Ottawa by parents from British Columbia and from Manitoba. She currently lives in Guelph with her partner, David, and their children Rajan and Denia.

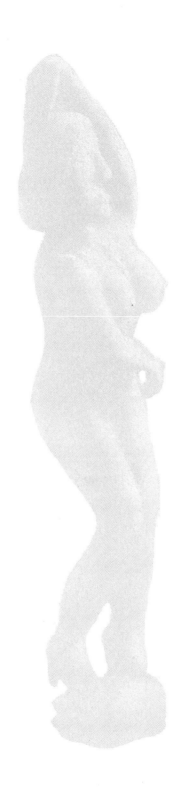

artworks

MCTUREG

NATIVE

Kenovjak Ashevak - *Riding On Mother Owl*

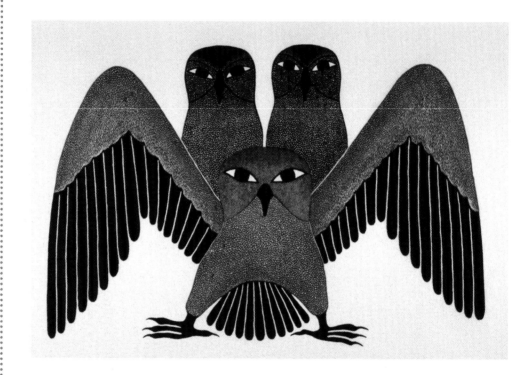

Joane Cardinal-Schubert - *the earth is for everyone*

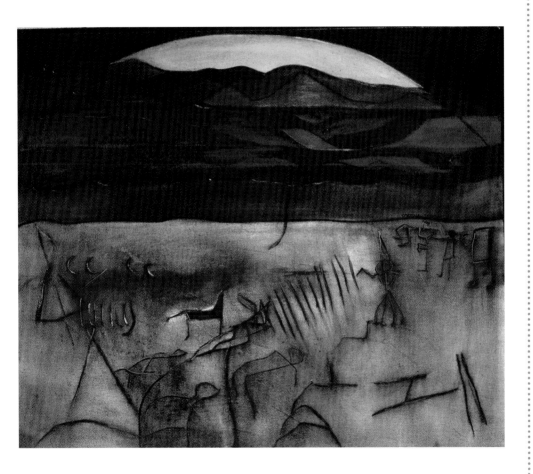

Shelley Niro - *A Day In March*

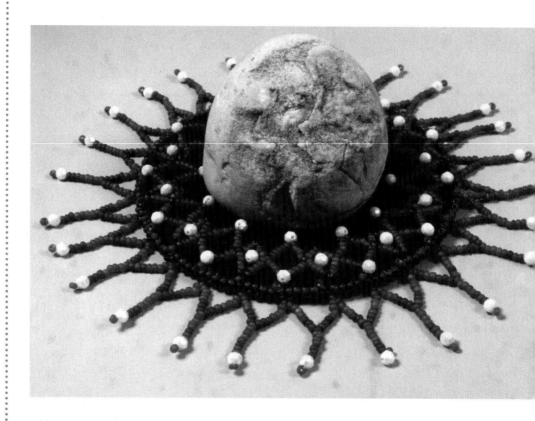

Dolly Peltier - *My Mother*

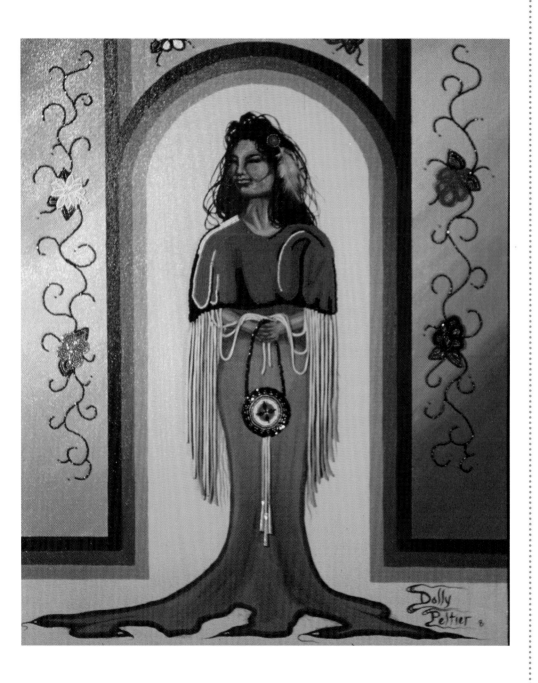

Merlin Homer - *The Beauty You See Around You Is Your Own*

Sondra Cross - *Rock Throwers of Lasalle*

Heather J. Henry - *How Do You Show That You're Indian?* (detail)

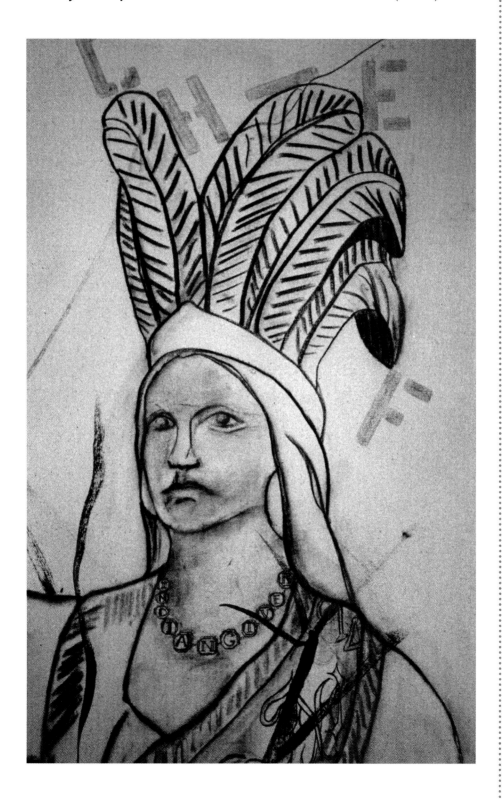

Maria Hupfield - *An Indian Act*

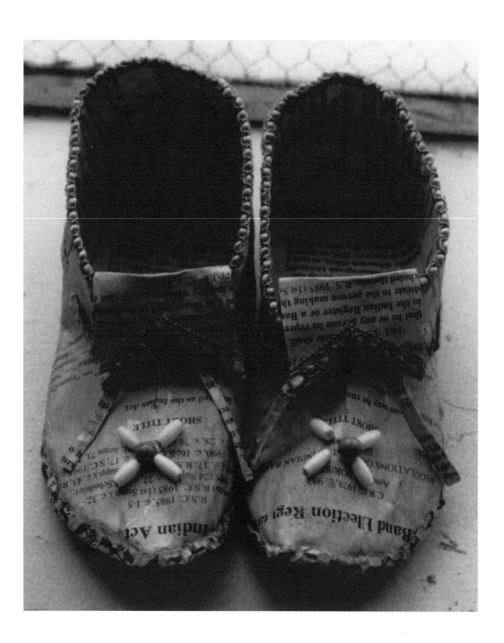

Doreen Jensen - *My Great-Grandmother with Lip Labrett*

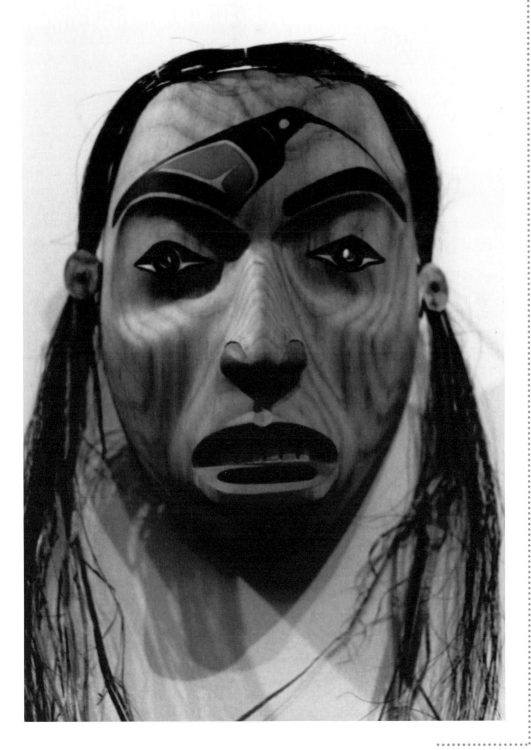

Artists

Kenojuak Ashevak

Kenojuak was born October of 1927 in Ikerrasak, and now resides in Cape Dorset.

"I just take these things out of my thoughts, and out of imagination, and I don't really give any weight to the idea of it being an image of something. In other words, I am not trying to show what anything looks like in the material world. I am just concentrating on placing it down on paper in a way that is pleasing to my own eye, whether it has anything to do with subjective reality or not. And that is how I have always tried to make my images and that is still how I do it. I haven't really thought about it any other way than that. That is just my style, and that is the way I started and that is the way I am today."

Joane Cardinal - Schubert

Joane Cardinal-Schubert was born in Red Deer, Alberta, and lives and works in Calgary. She attended the Alberta College of Art, the University of Alberta and graduated from the University of Calgary with a Bachelor of Fine Arts in 1977. Her work has been featured in more than 26 solo exhibitions in North America and Europe as well as numerous international touring group exhibitions. She has received many scholarships and awards for her work; notable is her election to the Royal Canadian Academy in 1985 and her receipt of the Commemorative Medal of Canada in 1993 for her contribution to the arts.

Shelley Niro

Shelley is a Bay of Quinte Mohawk from the Six Nations Reserve, now living in Brantford, Ontario. She graduated with honours from the Ontario College of Art, and received her Master of Fine Arts from Western University in London, Ontario in the fall of 1997. Her film *Honey Moccasin* has recently been honoured by receiving four awards from the Red Earth Film Festival.

Dolly Peltier

Dolly is Anishnaabe (Odawa/Ojibway) from the Wikwemikong Unceded Indian Reserve in Ontario. She spent her youth in the city where she studied illustration, graphics and commercial art. She is a mother of four children and receives inspiration from her family and her surroundings. Her paintings are three-dimensional and

include acrylic paint, beadwork and leather. She has been exhibited in Ontario and the U.S.

Merlin Homer

My mother is mixed blood, Salish from the Harrison Valley area in British Columbia and Mohawk from Kahnawake. My father's parents were immigrants to the U.S., originally from Russia. I grew up in Sea Cliff, New York, about 30 miles from the large Mohawk community in Brooklyn, New York. I belong to the Mohawk nation.

LauraLee K. Harris

LauraLee is Ojibway, Cree, Lakota, English, French and Irish. As a Toronto–born artist, she knew at an early age that visual art would be her focus in life. LauraLee studied at the Ontario College of Art and has been painting for over sixteen years.

Sondra Cross

Sondra Anen Karahkwenhawi Cross is Mohawk from Kahnawake. She studied Fine Arts at John Abbott College at St. Anne de Bellevue for two years, and recently began her studies at Emily Carr Institute of Art and Design. Her interests include painting, sculpting, ceramics, beadwork, leatherwork and making jewellery. In sports, she loves to paddle in two person, war, and single canoes. At the 1995 North American Indigenous Games, Sondra and her partner won five gold medals and one silver.

Heather J. Henry

Heather is Anishnabe from Wabaseemoong (Whitedog) Reserve in northwestern Ontario, and currently lives in Calgary.

"My relationship with different physical landscapes and my memories of growing up on a reserve have deeply influenced my work as an artist."

Maria Hupfield

Maria Hupfield is a member of Wasauksing First Nation in Ontario. She attained her Bachelor of Arts degree in the Art and Art History Specialist Program at the University of Toronto and Sheridan College.

It is through her art that she has found the visual language to celebrate her ancestry and to voice her concerns as a young Anishnaabe woman. Through her art, she creates a way of deconstructing the stereotypes that have informed a non–Native perspective

of First Peoples.

Doreen Jensen

Doreen Jensen was born in Kispiox, and is an artist, teacher, historian, curator, political and environmental activist. A graduate of the Kitanamax School of Northwest Coast Indian Art in Hazelton B.C., Doreen works in carving, weaving, jewellry, print-making and button blankets. Her work as a historian and curator includes the exhibition and publication of *Robes of Power: Totem Poles on Cloth*.

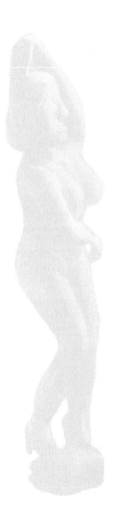

stories

EMERGING

NATIVE

Arrest This Memory

Before the oil slick covered our beaches, ducks waddled about most of the year round and every now and then the shotgun of some hungry family reported food for the day. IOCO, a local gas company, burned propane into the day and night across the inlet at Port Coquitlam. Coquitlam was still alive. He lived for seventy years after they named the town Coquitlam. They hadn't intended to name the town after him. It was that his English wasn't so good when white folks first came and the immigrants did not have the usual English accents. When they asked what the name of this place was he thought they were asking what he called himself. "Coquitlam," was his answer.

I never got a chance to ask him how it felt to live in the village which bore his name. I don't even know the real name of his village. I wonder now if he noticed. Since they never did learn to pronounce his name, maybe he didn't really know the town was misnamed, with his help. The mountains below Coquitlam and surrounding IOCO were still covered with cedar when I was small. Sometime after the environment became a general concern "Burnaby Mountain" was declared a "green area" to be forever protected. I hesitate to use the forever word coupled with protection, but then maybe trees have a better chance at realizing the foreverness of protection than do Native people.

The highway I lived on was a "one laner" that the bus visited twice daily, once at 6:30 a.m. to take you to town and once at 3:30 in the afternoon to return you home. My mom always believed that those hours were meant to make it impossible for Indians to find work. If you worked you could make it to town on time, but you would miss the bus going home. For a mile on either side of the reserve there were few white people living there – most were scared of us.

Down the hill below us was the beach. It was an amazing playground. Crabs, oysters, clams, mussels, seaweed were abundant. The only problem was that the sewer from white people up the hill drained directly onto the mud flats. My playground was a massive bucket of shit. Never mind, kids will play. In some strange way, this capacity to find joy while immersed in raw sewage still daunts, haunts me now. Playing in crap seemed to establish some sort of perverse sense of normal. Sometimes shit happens, blooms anyway, oh well, gotta take the bad with the good and that's their stuff, are all phrases that blind me to my sometimes bleak reality.

Home shapes. It determines the standard of 'normal' for the rest of your life. The relationships, the environment, the land itself calls you, names the gifts you need to survive, but it also calls up the familiar, the new is recycled from the past experience of home. Permissions you grant to others are conjured from your original home. These permissions indicate what you will or will not accept. Playing knee deep in raw sewage seems to get recycled by me over and over. I never seem to notice how bad my life has

got until sickness comes over me. About the only thing I won't accept is having to do somersaults while immersed in someone else's crap.

Our house was once a business: Carter Craft. The original sign was still posted long after the business died. Like an epitaph, it stood up on the house front, paint peeling with age, advertising its death. The boat shed below, empty and ghostlike, still housed the saws that once whirred all day long. Its emptiness, like the mill next door, appealed to our lonely spirits calling us to her hollow insides, both became the land part of our playground when winter rolled in and the water became forbidding. Buildings are not without spirit. The loneliness of a dead building not properly laid to rest established another norm for all of us. We all bear loneliness a little too well.

The house was once a boat shed belonging to the RCMP, when boat police were common. I still remember them. We once ran away from home; well, it was more like we tried to paddle our way away. We loaded up the skiff with bannock and our meagre brown bag full of clothes and paddled our way in the direction of Ocean Falls. We were only five and six years old and had no idea that Ocean Falls was some 300 miles away. An RCMP patrol boat caught us at the bridge – Lion's Gate – about four kilometres across the inlet as we neared the edge of the Georgia Strait.

They tied our leaky little skiff to their patrol boat and headed for the reserve.

"Are you from Cap or Burrard?"

I looked at my brother. He answered, "Burrard." We weren't quite from Burrard, more on the periphery, just one house away from the reserve. An Indian, living on the periphery of her father's reservation, not quite belonging to the "band," definitely not belonging to the white town. *On the periphery.*

I feel like that as a writer. There is something oddly and frighteningly comfortable about being on the periphery of some 60,000 readers' lives. I don't know them. They know a lot about me, but most have never met me. On the periphery, still, just like my home.

It took some time to reach my home. I wanted to see my mother running about the beach hollering for us. I looked at the house – no one was stirring. It would have been different if a frantic mother had appeared at the water's edge, worried about our absence. Some sense of belonging or significance would have been experienced by me. We rode by the darkened house, the landscape in front was blank, no one was looking for us. I felt smaller than I'd ever felt. We told the police we lived with Calidja. I only remember his nickname. He took us in in joyful silence. He was neither curious nor judgemental about our trip to the bridge. He never bothered to tell my mom. At dinner time, he just shooed us home.

Home. My mother died not ever knowing about our attempt to escape the willful and omnipresent loneliness of home.

I watched Vancouver rise before us from my side of the inlet. Innocent, young

and naive, the raising of a city both fascinated and frightened me. High-rises seemed to be born daily from 1961 through to the '70s. Hundreds and hundreds touched the sky. Cranes, men, rivet-machines, hammered and guided steel, concrete and glass to create these huge buildings that awed my childish imagination. That was power.

Just next to the old mills whose lights blinked out forever, one by one, was one of those homey cafes you never see anymore. It was narrow with only two booths and a long counter. An old dog slept outside its door, waking only once in a long while to wink at you as you rolled in for soup and a sandwich. My brother delivered papers there and on a good day the owner fed us a bowl of soup: a tip I suppose for our efforts. Mostly, she just exchanged a few friendly chat words with Ed and we left. Workmen ate there. They slid their eyes up and down and around us without uttering a word to either of us, hunkered over their lunch like they were all scared someone would snatch a bite. I remember not caring for them much.

I have few memories of being "looked after." Mom worked day and night at the crab shack on the beach, trying to make the cash she needed to provide for us. We had an old granddad who was supposed to be taking care of us, but he mostly shuffled between our house and my other grandpa's without paying too much attention to whether we were tagging behind or not.

I do remember standing behind the crab shack door listening to the women and waiting to hear my mom's delicious laugh peal through the melancholy loneliness that always seemed to enshroud my sisters and me. There was a little crack in the door. I would stare inside to get a peek at momma's hands, thick short fingers, pounding the flesh from crab legs and then she'd throw them up. The moment they disappeared, her voice rolled out tasty, wonderful and soothing words to the three of us.

I picked my sister Joannie up to have a peek at mom's hands. Joyce, the bigger one, would whimper to have a look too. I remember telling her she was too big. I tried, daily, all summer, and every summer she was too short. It shredded my insides to see her big eyes weeping with desire to see her momma's hands. I lifted, sweated and struggled but never did make it. I suppose this memory shaped me. I have a difficult time "giving up." Difficulty is putting it mildly. I confess, I am obsessed with success, obsessed with winning, obsessed with getting other people's needs met. I never give up and rarely take no for an answer.

Collapsing from overwork many years later, realizing that once I said yes I would never give up, I had to learn to say no. I did. As age and hard living work their effects on me "no" comes easier. At some point, before I die, I shall have to try "giving up" just to see how it feels. Today, it is easier to just count on others to give up on me, and they do.

When I do learn to give up, I shall give up remembering a mother who worked 16 hours a day hauling around cauldrons of boiling water weighing about a 100 pounds

and then some, day after day, year after year, and who managed to knit, sew, wash and feed seven children and then squeezed in the odd story sometime after eight over tea.

I shall give up remembering struggling for hours on end to hoist a thirty pound two year old, hour after hour so I would not have to feel the hurt children always feel when someone smaller whimpers softly. I will give up seeing her face, cheekbones, reaching up and out, eyes big black and round filling with salt water, welling tears finally leaking out in a thin stream of dashed hopes. I will stop hearing the soft elegant murmur she shrunk small so I would not feel guilty. She knew I tried. She knew I would try again. She prayed for thinness, but stayed chubby. All she wanted was the same glimpse of momma's hands that Joannie and I enjoyed.

It would have made her part of us in some deep way and she must have felt it. I have the memory of my failed attempts to appease her hurt, to integrate her with the snapshot of momma's hands and the texture of her laughing voice. My insistent trying, firmly burned into my memory. Years later I learned to be more creative about trying. If the first method didn't work, try something different, but I was four then, obsessive lifting was all I had to work with. I will see that small four year old, legs thin from less food than I required to live; hands willing, body refusing each time I considered giving up. I will remember the tenacity of my will and the lack of success framed by Joyce's big sad eyes.

I remember now, that home, the blankness of the walls, the wind bleeding through the odd missing board, the wiring hanging loose, no insulation, no inner wall, just the old shiplap that made up the original walls, the pot-bellied stove trying in vain to heat the place. I remember how it shaped me. I remember that a windowless room terrified me every day for eleven years. I remember a scared and willful mother, desperately trying to hang on to her children, develop some semblance of identity, lawfulness, love and joy, in a context too overwhelming for her to ever be successful. I remember, there was no man in her life to assist her in making her dreams happen.

There isn't in mine either. *Home. It shapes.* Our home inside was dark. Bare light bulbs in three of the five rooms. No windows in two of the rooms, one of which was for us girls. No moonlight for 4,000 nights. I love the moon now. I look at her every night. I have talked to her half the nights since then.

Home. It shapes. No man assisted my mother, none assists me now. No man shared her bed. None shares mine. No pictures adorned her wall. Mine are covered end to end. No matching plates. I'd rather not eat than not have matching dishes, silverware. No curtains on the few windows. My windows have lace curtains I made. *Home. It Shapes.*

I am at the Epicure restaurant in Toronto, trying not to remember home, sitting in the same spot I sat on that thundering night the last man I shared my life with asked me, "Your place or mine?" The dark wood and low light of the cafe speaks to the depth of the sinking feeling inside – like home, this dark, like home, the raw smell of

wood, like home. I play with the coffee cup, mindlessly. I don't see anyone but him. His face tilted to one side, his eyes wide, his chest holding down breath, precious breath. Five years later under the dim light of his home it was all over.

Some piece of me wants to understand why. It's a three year old question. I keep telling myself this. I struggle to resist the temptation to grocery list why this great love had to come to such a pass. Why my mother's great love had to come to such a pass. Why this carnival had to end.

Carnival. Carne: Flesh, levare: to remove. To remove flesh. Such a strange language which pushes up merry-making from two words which mean to remove flesh. My flesh removed lays bare my spirit. Bare like the walls of my home.

Inside my spirit resides my desire, a desire to have my flesh removed that I might become familiar with my spirit, discover again the spirit of my home, in joy, merrily. I chase after the image of the wish from some self-mutilating corner of me, that the flesh once removed will show me my spirit. Instead I see blood, my blood, pumping, racing, remembering, watching my blood feed the desire for the carnival atmosphere he created – she created.

She created laughter each night in the semi-light, sometimes in the dark on an empty stomach full of yesterday's hunger, sometimes in the cold, body crying out for warmth. She made us laugh. I was ensconced in it; drifting in the vortex of the storm of grinding poverty; laughing until tears leaked out the corners of my eyes; not caring about the hunger that dogged me all day; not caring that I found myself alone on the periphery of my father's village, the abscess of loneliness swelling inside that this ritual of laughter could not shrink.

I chase my hungry body into a corner, peek out at the chaos which drove it behind the chair, steal back the moments which birthed the need for carnival: shaking hands, jelly legs, emotional paralysis, terror – let it be over. I don't mind being hit, but I can't handle the chronic condition of hunger. I manage to crawl from my corner near the chair and volunteer my small body for my step-father's blows. I hear a cacophony of screams, "No, no please dad, I'll be good." They are coming from my brother, me, my brother, me, my sisters, "No... please, no... dad...he'll be... no... good..." become a crazy kind of chorus without rhyme, rhythm or reason. The point escapes in the terrific loss of consciousness in the minds of little bodies pleading for arrest. Arrest the removal of our flesh. Arrest this memory.

Arrest the laugh, then lights out – dark, dream, don't quit. *Home. It shapes.*

Lee Maracle

Lee is a member of the Stoh:lo Nation of British Columbia. She is the author of *Bobbi Lee: Indian Rebel, Sojourner's Truth & Other Stories, Sundogs, Ravensong*, and *I Am Woman*. She is a respected speaker and has integrated traditional Indigenous teachings with European education to create a culturally appropriate process of healing for Native peoples. Lee is currently the Aboriginal Healing & Wellness Coordinator, and the Internal Affairs Director of the Barrie Friendship Centre in Barrie, Ontario. This past year, she taught English at the University of Toronto's Transitional Year Program and is the recipient of "American Book Award 1999" for her participation in *First Fish, First People: Salmon Tales of the North Pacific Rim*.

Ni-danis "My Daughter"

On January 16, 1954, Emelda was feeling pain. Was it fatigue? Tension? Sore muscles? She had been cooking and washing all morning. Had she over-exerted herself?

She sat down and sighed. "Soon," she thought. "Perhaps tonight." Emelda caressed her stomach. The baby kicked, longing to be free. Emelda squirmed, "I must get ready. It's already dark and late."

The nearest hospital was in Geraldton, 25 kilometres away. Emelda would need a ride. She packed a small suitcase with necessities: diapers, blankets and a change of clothing for herself. She also included moccasins to sell. She would need money. The baby kicked once more.

Emelda stopped to hold her breath. Her six children continued to play and tease each other, unaware of their mother's pain. "Get ready for bed," she told them. The girls huddled together in one bed, and the boys in the other. She covered them with quilts and asked them to pray. "Our Father who art in heaven..."

Emelda called Isquashish, a live-in auntie, and gave her a few babysitting instructions. "I'm leaving now," she said. She gasped in pain as she sat down to heave her boots on. Slowly, she put her coat on, tied her kerchief around her head, and put on the beaded mittens she made for herself a long time ago. Isquashish handed her the black suitcase and Emelda turned towards the cold, wintry night.

She shivered in response as a gust of wind greeted her. She stepped boldly into the darkness, toward the flickering lights of Longlac. From there, she would take a taxi to Geraldton.

As Emelda walked along the highway, her thoughts flashed back to the days of the midwives. They were quiet, smooth and efficient. Today, mothers are forced to rely on hospitals and doctors.

Emelda made it to the highway and saw faint lights in some homes on the reserve. The church was at the centre of the reserve. The tallest building there. Emelda's eyes searched in the darkness for a glimpse of the cross. She began with a litany of prayers, "In the name of the Father, the Son, and the Holy Spirit..." She moved with the rhythm.

The town of Longlac was within sight now. She followed the welcoming sight of the lit homes. Once she reached the bridge, the town would be in full view. The rhythm of her prayers continued.

Her thoughts went to Sam, her husband, working in the cold weather. Had she forgotten to include the long-johns and shirts when she packed his bag for work. The weather was at its worst in January. "Poor Sam," she thought. The railway often took him away from home. "Bye Wifey," he said as he left for work that Sunday night. "Let me

know when the baby comes."

Emelda felt solace when she approached the town. The cabs were near the highway, next to the gas station. She trudged on and headed towards Billy's Taxi. Only a faint light glowed. She knocked, but no response. She knocked again, more loudly, but still no response. She tried four more times. "No need to be alarmed," she thought. Emelda turned and plodded toward Don's Taxi across the road. She knocked.

"In a few moments, I'll be in the warmth of a taxi and then the hospital," she thought. Her feet were beginning to feel numb from the cold. Don peered through the crack of the door and said, "Sorry, no trips tonight," and started to close the door. "But, I'm going to have a baby!" The final click of the door latch was her only response.

Emelda braced herself and turned away towards home. A sharp pain penetrated her body and she stopped. She propped herself on the suitcase and breathed slowly. The pain was gone. Emelda had to beat time, so she increased her speed between each contraction.

Her suitcase came in handy. She could sit down, and after a few long, slow breaths, she was off again. She seemed to be floating, flying, as she headed down the highway toward the tracks. The contractions were coming closer and closer. She pleaded with all the saints to assist her. "Most sacred heart of Jesus. St. Ann, help me." Emelda's face cringed with pain as she sat on her suitcase again. "Not far now, I'll make it," she told herself.

She rushed her steps, and like in a dream, she was suddenly inside her house. The oil light had gone out. She lit the makeshift light of grease and a rag and called for Isquashish. "Go get Nokum," she whispered. "I couldn't find a taxi." Auntie Isquashish knowing the urgency dressed quickly and stepped into the cold night.

Emelda's knowledge stood the test. She prepared for the delivery, remembering all that she needed from past experience. She shook Louise, her eldest daughter. "Get me a bowl of water, scissors and a rag, and set the slop pail near my bed."

Louise ran around in tears, afraid and confused. She tried to get water out of the pail, but it was frozen. She frantically cut the ice with a spoon and was able to retrieve some water. Emelda was oblivious to the cold by now. She was inside the house, away from the freezing temperature.

Emelda unpacked the suitcase and placed the baby items by the bed. She placed the statue of Mary on the table and a bottle of holy water. She wiped the scissors with the holy water. "This will sterilize it," she thought. She took the rag and ripped two strips ready for the umbilical cord. She remembered her mother saying, "Never cut the cord too near to the baby's belly."

The oil lamp was now flickering. "Go to bed now, Louise." Emelda laid down. The contractions were coming in succession. The baby could no longer wait. Breathing in rhythm, Emelda pushed and prayed and prayed and pushed. Not one sound was

heard except for the breathing. The head came first, then the tiny shoulders, and the rest of the baby slid out into the world without any complications. Emelda was perspiring and tired. She reached over and cuddled her daughter, "Ni-danis," she whispered.

She then smacked the baby's bum. The baby's cry broke the stillness of the night. Emelda's task was not over. She wiped the baby's face, took strips of fabric and tied the cord in two places. Then, she took the scissors and freed the baby. She bathed the baby and wrapped her in a blanket. She listened to her breathing. A new breath in the world.

Still it was not over for Emelda. She knew the placenta must be removed. She placed her hands at the top of her belly and pushed one, two, three times, and out came the "pillow" as she called it. Now, in sheer exhaustion, Emelda fell asleep. She dreamed of making fire, heating water.

Nokum rushed in the house with Isquashish following close behind. Ni-danis, do you need to go to the hospital? Suddenly, she saw the baby. "Ehhh, Ni-danis," she whispered.

Weeks later, Emelda was on her way to the Hudson's Bay store. She held her baby Theresa in a cradle board. She happened to pass the taxi stand. "Taxi?" the man called.

Emelda didn't answer him.

Ann Wesley

I am Swampy Cree from the Constance Lake First Nations Band, and presently living in Millet, Alberta. I am the Vice Principal of the Ermineskin Primary School in Hobbema, Alberta. I served as Principal for three years and as a teacher at the same school for twenty-two years. I have been of service to the Plains Cree people of Hobbema for all of these years, and I have learned from them as well. I am fifty-nine years old, and my interest in writing began in 1993 as a result of having to write speeches at Toastmasters.

I come from a family of 16 children, eleven girls and five boys. I am the third eldest girl. I have never married and have no children. Needless to say, I have many nephews and nieces.

Crystal, The Fancy Shawl Dancer

Hi y'all my name is Crystal and I'm a fancy shawl dancer from Oklahoma. Well I dance on the pow-wow circuit every summer. I'm one of the best dang shawl dancers in these parts, probably the world. We compete against each other in our contests. Sometimes it doesn't only have to do with dancing. There are some politics involved. It depends on who you know, who your family is and how many times they say your name on the microphone. You gotta know where to stand and sit, so everyone can see you. If I really want to win, I wear my MISS INDIAN WORLD banner and crown. They call me into the arena, and that's when I give them this big pow-wow smile and the Indian princess wave. You see there is a technique to the wave. This one is called screwing the light bulb. You don't twist, you just ever so slightly screw.

I do my best politicking on the dance floor. When it's time for my contest, I spot out the judges. They usually stand around the arena. That means I have to work my way around the arena once so every one of the judges sees me. What you're judged on are the fancy steps you make on the honouring beats. Now I know that Indian music sounds the same to you people, but those are the beats during the song. Now I'm set, I know exactly where my judges are – they are on that side, and the other two are behind me.

My shawl moves and I use my shawl like this, spinning and it goes like this, and complicated foot work moves and it goes like this: ready – step, step, step step hop – the crowd goes wild. Then I get in the middle of the arena. The music picks up. I spin faster and faster until I can't stop because I need to be number one. I need new sneakers!! Then I stop on the very last beat of the drum. I do my special stop. When I'm done, I stroll over to line up so the judges take my number and when they ask for another song I just say, "Gee I thought that was just a warm up, Aaaay."

This year is my first year of college. I got to learn a lot of great things in school last year. I really fell in love with Shakespeare. Lady Macbeth she turned me on. Especially when she started talking about how she was so ambitious to be queen that she would take her own child from thee breast and kill it onto thy floor to thy hearth to succeed to be queen of and use all thee powers of darkness to be set on thy throne. Now that is ambition. I wonder if Shakespeare knew any Indian women.

When I left for school, one of my aunties, she gave me an eagle feather and she told me to forget about everything back here for awhile because everyone will be fine without me. She also told me that just because I get educated doesn't mean I'm not an Indian anymore. She also said the only way we are ever gonna get ahead of the white man is to always be one step ahead of them by going to school. I remember what she said when I went away. When I got to school it kinda surprised me because there was so

many white people I don't think I ever seen that many. You see, when I'm back home I'm one of the prettiest girls in these parts and when I walk into a room all the Indian guys just stop and try to snag me up. It must be because I'm such a good dancer, Aaay! Anyway, when I got here nobody paid any attention to me. They didn't even think I was pretty just because I wasn't white. So you know what I did? I did the same thing here that I do at home. I got to class first, did my papers first, had all the answers first and sat up by the front of the class first. That's what those people get for not thinking I'm pretty, Aaay.

School really opened up my eyes to a lot of things. It made me take a long hard look at my friends, my family and even myself. When I came home, I went to a pow-wow with my dad. I saw this little boy in a fancy dance outfit. He sure was a good dancer, but nobody was paying any attention to him. Then I noticed that he wasn't all Indian; he was mixed with Black. I felt sorry for this little boy because I knew that he wasn't accepted. Later on that day I asked my dad about this little boy and he just laughed and said, "No, there is no such thing as Black Indians!" When he said that to me it put a chill through me. I couldn't believe the ignorance of my dad. I couldn't figure out why he was so mean. I realized that it wasn't that dad was afraid of Black people. It was the change. When he said that to me he was saying that change isn't good. My dad came from a different time of survival. So much was taken away from us he had to hold onto something. He wanted me to know that this is his world and even though I am going to college, he wanted me to understand that this world he created for me to survive in was protected, and change was no good.

I don't know about this life. I go to pow-wows. I see the older women competing against each other and I wonder are they really satisfied or are they just surviving. I don't want this life that I've seen so many of my friends and relatives have. They fancy dance and travel until they meet a guy that they snag up. Then they get married, buy a trailer or a van, make outfits for their kids, become traditional dancers and watch their children do the same dang thing. Don't get me wrong – I love to dance, and I'm proud to be an Indian. There is so much out there to see, understand, and learn.

Well I gotta go, grand entry is being called and I have to dance real hard today. There are 13 girls in my contest. I'm gonna kick some butt, Aaay. Okay, see Ya!!

Murielle Borst

Murielle Borst is Kuna/Rappahannock and grew up in theatre with Spiderwoman Theatre all around her. Her acting and dance training began at a very young age. She debuted as a dancer at the age of two with the Thunderbird American Indian Dancers and is now their principal female dancer. For the most part, Murielle was raised as an urban American Indian in New York City, but she did spend much of her teen years

on the Southern Ute reservation in Colorado. She received a Bachelor of Arts in theatre and dance from Southampton College and interned with Spiderwoman Theatre. Murielle is married to Native dancer/musician Kevin Jarrant and is mother to their daughter Josephine. This monologue is an excerpt from an original work called "More Than Feathers and Beads."

Dear Marie:

I know that you must be pretty frightened to be away from your parents, family and friends. It's hard feeling like nobody wants you. But you're the oldest and you have to be strong for the other kids 'cause they're in the same boat as you. They look to you for guidance 'cause they don't understand what's happening.

It's really hard being shuffled from home to home – having to keep saying to yourself and your brothers and sisters that your mother and father really love you, they're just having a hard time right now. (In my mind I kept saying please don't send us away. I'll be good. I'll do anything. Please...)

It's even harder when you find you like the people in a home. You try not to show it because you just don't want to get moved again. If you get attached, they move you. You're temporary, don't get attached. You can't be moved. Your brothers and sisters can't be left to fend for themselves. As the oldest it's your responsibility to look after them. Mother will be angry with you if you let the family be broken up again, even though she's not here.

You know that it will be easier for your parents to collect you if you're all together instead of split up. You want to make it as easy as possible for them to take you back when their troubles are over.

You're scared you'll make the wrong move or decision and teach your brothers and sisters the wrong way to do things. You're really scared because your mom told you how to act and what to say when it was time to say it. But she left out all those middle parts: like what is the right and the wrong way to be around other people rather than always remembering "you're just a guest."

Before you go to sleep every night you pray that none of your brothers and sisters mess up. Because you're not being able to get close to the family that is looking after you – at least you'll have each other and so long as you're a family you have someone by your side. Even if your parents do keep giving you away.

It's really hard trying to keep together those of us that want to stay together.

I'd like to scream No! I don't want to do this.

Marie Pruitt

Marie Pruitt is Ojibwe and now lives in Barrie, Ontario. She is a grandmother of four grandchildren, the eldest of whom is nine years old. She wrote this piece to reconcile herself to the many times she had been placed in foster care, due to her mother's poor health.

This letter is to herself as a little girl.

Excerpt from Moose to Moccasins

I remember the pines, the great big white pines, the cedars by the shore. The pine cones on the forest floor, the little clearing for our summer tents. There were no docks, only the canoes drawn up on the shores, no kickers, only the calm of the water, occasionally broken by the steamboat. Everyone paddled then, even the tourists. For some of the Bear Island people of today this may not seem true but it is, I know. I was there – Bear Island, my home, as I remember...

I remember when I was very young. Then Temagami Lake was a beautiful lake. There were only a few tourist camps with tents. Tents for sleeping quarters, tents for the dining room and a tent for the kitchen. There was only one little motor launch owned by Mr. Orr, the owner of Wabikon Camp. His daughter, Charlotte Orr managed the camp, large enough for 200 people. The lake then was very special with a lot of good fishing. It was so quiet with no noise at all. When the loons called, the water would vibrate. Everyone paddled to get around the lake. The only other boat at that time was *The Belle*, a large steamboat, operated by Dan O'Connor. The steamer brought both passengers and supplies to Bear Island for the summer. I remember first Captain Marshall, and later Captain Ted Guppy looking after *The Belle*.

The Hudson Bay Company used to rent canoes to the tourists, as well as tents, Hudson Bay blankets and supplies. Indians used to do the guiding for the tourists taking trips for two to three weeks travelling through the wilderness. The Indian guides saw that they were safe. I worked for only two weeks and made two dollars at Camp Wabikon. I would have stayed longer, but Great-grandma needed me at home to care for her.

In those days there was no school, but Indians were highly educated in their own way of life. They used their own experience to do many different things and knew how to survive and exist in the wilderness. There is so much to learn about bush life. You have to know what game to get at what time of the season and what animals are ready for the season. As well it is necessary to know what animals are good to eat and at what time of year, what kind of animal furs are good to sell and when in the season they are good to kill. All those things have to be remembered.

Most things you'd use were made of the raw material supplied by nature. Living in the wilderness means nothing is made by factory. Everything is made by handwork and made out of the woods. This is a lot of hard work, but can be a very healthy life. The woods were clean, the lakes and rivers were so clean you could drink water anywhere, not like today. All Indians made a good living in the woods until their lives were changed by the white man. Indians never harmed their country or wasted any animals.

We only killed what we needed in the way of food and we made use of everything. When white man came to hunt, he used poison on animals. Many animals were never found and they died in the woods where no one travels. The animals and birds were pretty well cleaned out and have been scarce ever since.

When we were in the bush we made our own recreation. Some evenings Great-grandma, Grandpa and myself would sit around the table and sing. Other nights we would be playing on the checkerboard Grandpa made from cedar wood. The black squares were made by rubbing charcoal on the wood. We had homemade games carved out of wood and brush and leather strips. One interesting toy was a 'dancing doll,' made out of wood like a marionette that lay on a flat board. When the board was hit, the doll would step-dance. We enjoyed our evenings, just the three of us, far back in the woods.

All winter, we burned only animal fat for our lamp in the evenings. We had fat oil in a tin dish with a rag wick weighted to the bottom to keep it in oil. Then the floating rag would be lit and we would have light.

We received mail twice a year at Christmas and Easter. Christmas was always a religious day for us. We always had a roast of beaver for Christmas dinner stuffed with raisins and flour dough for a dressing. We would have cranberries with baked beans in place of potatoes. That was our Christmas feast.

We were very happy in those days. It was a hard life living in the woods but we didn't know differently. At night the log house used to be cold soon after we turned in. The fire was allowed to burn itself out. In the morning Grandpa used to have birch bark on hand to start the fire with lots of dry wood to have a quick fire warm up the house. Every morning in the winter our water pail would have one or two inches of ice which had frozen during the night. We, however, never felt the cold as we all used a rabbit skin blanket, a very warm, very cozy cover no matter what the temperature in the bush. We even used rabbit fur to circle our toilet seats. Living in the bush did have its comforts.

When I was fourteen years old, my mother, Elizabeth Petrant, died. She had delivered twin boys and died from their birth. Five children were left behind. The twin boys were placed with their aunt, Maggie Moore at Bear Island while my younger sister and brother came to stay with me and our grandparents. My sister, Lena Petrant, was five years old and my brother, Donald, ten years old. My step-father left for Quebec and got married again.

In September of that year the five of us went to the bush at Grandpa's hunting grounds. He and my brother trapped together. My great-grandmother, my sister and me trapped around Diamond Lake as usual until the lake froze. During the winter months, I set rabbit snares. In the month of May, we came out of the bush and spent the summer at our village on Bear Island.

I never really spent much time with my real mother, but I always felt I had parents and a family.

Reprinted from *Moose to Moccasins*, published by Natural Heritage Books, Toronto.

Madeline Katt Theriault

Born in a tent on Bear Island, Lake Temagami in 1908, Madeline Katt Theriault was delivered by midwife Angele Whitebear. Madeline is of the Teme-Augama-Anishnabe, the deep water people, and now resides in North Bay, Ontario. She is the author of *Moose to Moccasins: The Story of Ka Kita Wa Pa No Kwe*, and is a great-grandmother of nine, grandmother of four, and mother of three children.

Ama's Home

It's all built on pre-Cambrian rocks by little lakes, rivers, ponds, big lakes.
Great Slave Lake. Great Bear Lake. Rat River.
Close your eyes now, O.K.?
You are on a twin engine plane. It has pontoons. It lands on the cold lake by the village. There is sweetgrass growing by the docks.
You leave the plane.
Green grass electric blue blazing rose cherry red wowzam pink under the sun green umbrella trees –
Porcupine quills, fish scales rosy with berry juice...iridescent flowers sewn on brown velvet moose and caribou skin jackets and moccasins-
In the green grass –
Hot machine smell of oily smoke as the silver airplane fades away in the flying blue clouds –
The aunties and uncles and cousins waving turquoise and lime and cherry apple blossom coloured scarves – waving shawls and lazy birch switches. Good-bye.
Good-bye to the plane.
"Oh, praise the Lord. Praise God, we made it. This is my home. You. This is where I grew up in that damned convent," said Ama.
Chamomile-golden buds in the grass, sandy roads with smooth pebbles, one room log cabins, canvas teepees to smoke fish, weasel houses –
"Nah," said an auntie, "Those are no weasel houses, those are mink dens-a long, long time ago, when I was just a little girl like you. Oh, that was a long time ago!" And everyone laughed. "There were French brothers here then, from Quebec. They wanted to make some stumpah, some money, for their mission here, eh? So, they built those mink dens to raise mink and sell the fur. They didn't know how to go out on the trap line like everybody else. Humph."
Anna and Violette, Ama, and all the aunties, uncles, and cousins, thumped along the silvery boardwalk through the seagreen mist of the shore. They carried the duffel bags and shiny metal blue suitcase to the little wooden house on the edge of the field where the mink dens slept in the waist high grass.
Then Ama boiled some tea, an old auntie unwrapped some warm bannock from a tea towel, and the uncle cooked some fish outside, over the fire.
After, they sat and drowsed under the spring lace of birch trees. It was very warm. Fat blue flies buzzed low and heavy over the empty enamel plates. Ama told them about the Little Buffalo River where they would be going by boat the next day.
"Because a long time – oh, many many years before the whites and the mission came,

and even for a little while after, there were salt banks there."

"Ama? Salt? Real salt? Like what we put on meat?"

"Real salt, my girls. It looked just like snow, there was so much...yes, piled up like snow banks, salt banks all along the little river. On both sides, as far as you could see. And sometimes in the evening, my own mama, she would wave to my little brother and me

shhhhhh

she would whisper just so we could hear

and we would come so quiet.

All along the banks the buffalo would come to lick the salt. Just like candy.

Oh it was a big treat I tell you, for them to lick that salt. Hey-heyyy, my heart."

"Mama? You're crying, Ama?"

"No, it's alright. Well. The salt banks are gone now.

No more buffalo in these parts. Still. The Little Buffalo river they call it.

Yes.

I was born here, where the buffalo were, and the salt.

That goddamned white man."

"Ama?"

"Yes, my girl?"

"I'm part-white, eh?"

"Yes, my girl."

Frances Beaulieu

I was born and raised until the age of sixteen years old in Yellowknife, NWT. As a Métis, I write stories for myself, my brothers and sisters, our children and grandchildren. I hope they will be of interest to anyone who has faced confusion about their ethnic identity, experienced prejudice and racism, or suffered the loss of birth parents or family.

Excerpts from a journal "Travelling to Malaysia and then Home"

Throughout the whole time between receiving an invitation and attending the 1998 Commonwealth Writer's Conference at Kuala Lumpur, Malaysia, I kept a journal.

August 17/98

I'm off to Malaysia! Received the invitation from the Writer's Union Foreign Representative requesting that I be the ambassador for the Aboriginal writers. I'm to read, sing a song and participate in whatever I'm called upon to do. And would I bring my traditional dress?

I don't know where Malaysia is except somewhere in my dumb brain I know it's very far. Far East someone says. Very far. Somewhere near China. I don't have any preconceived ideas on what to expect and I don't have time to read any literature. Oh well. So be it.

September 04/98

Flight time is twelve hours and forty-five minutes; eat, watch a movie, find a comfortable sleeping position, scrunch, listen to music.

The Eastern sun sings loudly. Heat and Light fills my window – I wonder what I'm supposed to learn. What lies ahead? Through the crack between the seats Joan passes me her books on Malaysia. We contemplate what we can take in during our free time, if we have free time. Below the ocean liners burrow through white caps. A voice informs us that there are eight evacuating signs we should pay attention to. Great way to instill confidence.

Mountains look like they're covered in moss. The ocean is dark dirty emerald green. I can almost smell it. High-rises look like cubicles. Exhaustion is written all over the land. China is an old, old country after all. How sad to see her tiredness. How much can she stand? When will she break? How? What can they expect?

September 05/98

Pearl Seaview Hotel appears to be tucked away into itself. Nothing like the conceit of our hotels in Canada. Our room is TINY. We squeeze in our luggage, press against the wall to pass one another and laugh at the smallness. After we freshen up we head into

the evening to buy bottled water, a snack and book for the morning airport shuttle. Exhaustion eats us and we call it a night. We wake up freezing to the sound of ancient thunder; its guttural laughter electrifying the sky. Time change is a jealous bitch and our bodies feel it. Hard to sleep when the body wants to walk. The scent of my family rock is strong having captured all the years of ceremony. I didn't notice the smell before. I hug it beneath my pillow grateful that home is with me.

September 06/98

Breakfast is expensive. J. pays for our room. My turn when we come home. The bus ride gives us a closer look at the city and the country. I can't get over how tired the land is. I feel its wrinkles. Its weariness. Its heaviness. Its groans. It's like watching a starving dog no longer able to move because of brittle bones. I'm floored by the extreme between technology and the famine. I'll be able to absorb more when we return. And yet it's no different from home. Poverty and the well-to-do live side by side. The starkness and extravagance is a human condition that is so familiar. I've lived both yet I have always found the contradictions unsettling.

I call home and mail postcards.

I don't understand the language spoken here yet it's familiar and I find it comforting. Bye China see you on my return trip.

Malaysia. Oh the airline is something else. The service and style are exquisite. The flight is about four hours. I've plenty of time to ponder and write.

Malaysia. Miles and miles of palm trees. Are they coconut, pineapples, palm oil? What are their resources? Look at the beaches! Get a load of that! Red soil looks like Australia. I'm going to love it.

We are greeted by two smiling Malaysian men. And brown people galore! What a treat not to be a minority. I'm home. They take us to the airbus, another smooth-sailing boat. Our bus driver loves good music and pumps out the beat. Our eyes are glued to the window. I catch a glimpse of a large iridescent blue bird. I hope I see one again. Wish I had a bird book.

Better housing here though there are shacks of corrugated wood and tin roofs perched on stilts among the rows of palm trees. Reminds me of the sugar beet plantation and my people hoeing in southern Alberta. One must do what one must do for a living. At least there is a sense of accomplishment if only for survival.

We sit through the introductions. I want to think that the conference is evenly represented by men and women, but it feels like there is a dominant male presence. Again I am comfortable with the powerful majority of brown people. Too often I'm the minority among non-natives and this is a welcome change. Human nature being human nature we size each other up. Who cares if we don't speak each other's language; regard-

less if it is the colonizer's language, we speak freely in English. Malaysian being the dominant language, the conference is peppered with English to accommodate all the foreigners. Tomorrow, we are informed, we must wear our traditional wear. Oh gad, the buckskin dress! Oh well, I'll wear it once – for the dignitaries.

September 07/98

Lots of academics who are creative writers. They will talk about deconstructing the colonizer's language and read their works. Many work in all the genres. I go through my conference kit scanning the essays. My insecurities surface like dark dogs. I'm "just" a poet, I tell myself. Still part of me knows I could present a paper just as well as any of them and I'd have as much to say. I'll wait to find out what is expected of me.

Everyone is dressed in their traditional wear and the Malaysian dignitaries arrive. Each gives a winded speech, their tongues in Malaysian crescendo stressing the importance of literature. Some of the text sounds romantically reassuring, the theories however need to be challenged and I'm SO tired of political jargon. But it's a safe place to hide. I wonder how their theories will be applied in their creative works?

"Literature provides knowledge, instruction, and entertainment." "A silent people is a dead people." Gad, that is a presumptuous statement. Does that mean people who come from an oral society haven't contributed to humanity? Sometimes it's the paper writers who make a mess of everything.

Later, some of this introduction is translated. I get the impression that there is heavy censorship. The day has been long. My ears are stretched from listening and I'm sure my behind has expanded several inches. The week is going to be long.

I've been asked to read "one" poem tonight. I've chosen to read "Returning" from *Bear Bones*. Why hide what happened to Canadian Indians? I'll give them a view of our history.

September 08/98

Gee, its only Tuesday. Sleep was an evasive mistress. I do hope the day rolls smoothly.

I feel like I've been here a very long time. None of us has wasted any time getting to know one another. I think if I can permit myself to be broad in saying coloured people have no reservations in exploring friendship, laughter flows freely, we seem to have fewer hang ups. Of course, there are bound to be some class structures and religious differences and gender politics, these are inevitable. Human nature being human nature we sense these things about one another and, in bits and pieces, some of us shed these superficial boundaries. Our time together is short, who knows if we'll ever connect again. I've been sensitive to this all my life. Make every minute count, at least work at it.

Conference notes: "...reflections change even at the point of delivery." Ah, yes. "...personal agony in writing." Of course, been there many times.

"Fact and fiction, where do I draw the line without giving offense to my siblings and my family, how far do I go? When and where do I push the boundaries? And if I risk, what am I risking and jeopardizing?" Serious questions every writer must answer at some point. I know these have scared me half to death.

"Geography determines the history of the writer. Geography is my history." How about my interior and exterior landscape in my soul?

"A writer must learn to heal rather than scar. Heal wounds, memories of the past or be a reminder?" Gee, how can we be so presumptuous as to think we can heal anyone's scar? Is he suggesting we must protect others from the evils and hurts of reality? When does a person grow up and accept the challenge of their pain as they discover it in writing? Unfinished business I'd suggest.

"My life in literature is a convoluted passion." All right! Thought. My father wanted me to be a lawyer. Gad he was ambitious for me. I couldn't even add 2 and 2, for heaven's sake. This statement has me thinking about what lawyer means in Cree. Lawyer is a person who "tricks" with a "play" on words and actions which appear to be "lies" and Wisahkecahk was a master Lawyer/trickster. This learning after all is for self and others to turn the mirror and see the many angles and draw their conclusions. I figure my father was wise and I've met his dream. I'm a poet. Hark, hark! Convoluted passion, for sure!

My mother on the other hand thinks I'm a political activist, my travels entailing the struggle for land rights. She doesn't understand I write poetry; still in an ironic way she's right. Geography, landscape and the oppression I've observed and experienced do appear in my work.

Speaking the truth requires a person to prepare for a certain amount of silencing. Truth does not require sterile language. "Return to the 'village home' is also the final rest." I love that analogy. My Elders would enjoy sixty-some Sir Paulias Matanes from Papua New Guinea. 1,000 different tribes, 800 languages, each person speaks at least four. Wow!, and Canada fights for only two, as if they have superiority above others. And we think we are so accommodating. Hmph.

September 09/98

Today is my beloved's birthday. I'll call home if I can figure out the time difference. I still don't get it. I'll have to search for the "unique" gift. He tells me "to take the high road." Sometimes I cannot. I have to give myself permission to feel everything. The bear in me is fierce and it needs to root in its own interior and apply its own salve.

"Let your flying fox fly" – the source and centre of the human being is the heart

and lungs. Maori saying. Beautiful. Why didn't I think of that. "The Ocean is a sacred space."

"Art is not a mirror, it is a hammer." I love that, don't spare me from learning.

For dinner we are served a traditional Chinese Malaysian meal. Ann is a Chinese Malay. We compare notes on how we "eat" everything as I pick through the eye-sockets of the fish. She volunteers to take us to several galleries after dinner. Finally the afternoon is our own. Till now we haven't had an opportunity to go about. She also takes us to the Central market where she teaches us how to barter. She's extremely help-ful and generous and we are all grateful.

At the supper table an Indian woman from Fiji asks me if I'm a "Red Indian." For a minute I'm shocked speechless. She sees this and apologizes for she doesn't know how we are referred to. I recover and laugh and laugh. I haven't been called a Red Indian since god knows when. I forgive her, after all how would she know?

Later LC tells me that someone asked her if Canada had "Red Indians." "Louise is a Red Indian," she informs him. Apparently, he craned his neck to stare at me.

Last day of the conference. Many of us have become lifetime friends. Zelila has been asked to interview one of us for their nation-wide magazine. She chooses me and we have a frank discussion on poetry and the truth of writing. She tells me Aries women write the truth and she will translate as closely and as beautifully as possible. I'm asked to read "one" poem at the closing ceremonies. Their poet laureate has carried on and on, time is limited. I decide to read from *Blue Marrow*, the theme of migration and its con-sequences.

Panel discussion is heated. Dr. Zawiah, who has been an assertive questioner all week, delivers a passionate paper written the night before and receives a standing applause. It's the best yet!

Unfortunately we won't receive a copy of her presentation so she suggests we buy her book. I tell Zelilia it isn't fair to expect us to buy her book when it's her paper we are interested in, so what are the chances of getting a copy later? She'll check into it. I want to be able to read her paper critically because the issues she draws up need fur-ther investigation. How do we ever move out of dominant influence over our works using our own cultural histories without using the English language? Are further alien-ation and disharmony being embraced? I don't buy it. I truly believe we don't have to give up our identities because we've adopted English as a universal tool. Anyhow, we are all invigorated by thoughts she's raised.

The conference is drawing to a close. We are all exhausted. Good-byes are said. I'm off in my own little world experiencing the impact of this journey. I've contributed, yes, and experienced all the highs and lows like everyone else. In heightened awareness I wonder how I can express this immense growth right from budgeting to researching, who could sponsor me to the nitty-gritty of packing and gathering of books. My spon-

sors asked how I would expect to represent Canadian writing and how would this experience contribute to my writing enrichment. I've observed the poverty, walked in its smells, gloried and felt Canadian shame at the extreme generosity of our hosts and hostesses. I've found commonalities in human nature, and felt challenged by our differences. There is so much to process, I go inside myself continuously exploring my reality and theirs. Every emotion and thought I've experienced has been worth it. How else can one become aware and move beyond one's comfort zone except by submerging into another culture? Another world?

Naturally, the three of us have experienced and perceived the conference, the people and the country differently. Joan, I think, is politically astute and articulate with her observations. She knows the jargon and can fit the political puzzles in ways I don't know how to. Lorna observes and delights in the oddities. I absorb with my skin and with my heart which sometimes makes me uncomfortable.

They call us "The Three Canadian Ladies." We howl with raunchy laughter. Read our stuff, ok!

Writers work alone or so we think. We suffer a sense of alienation, separation, fears of abandonment and rejection, and go so far as to believe in our own annihilation. And if that isn't enough we are filled with self-doubt, confronted with moral and ethical dilemmas about what we think we should or should not write, and then are faced by the tortuous task of getting it down on paper with style and truth in a creative format. The reality is, at least, for me, I must be in social intercourse with the world around me. To feel, to sing, to dance, to shout, and to drink in the plate of delights and ambiguities Creation has dished out. I must nurture and be nurtured to be creative.

This trip to Malaysia has been different from any I've taken. How so? I was going with a keen openness which years of writing has prepared for me. I find it difficult to articulate this awareness, although I'm constantly stepping in and out of my skin and beyond my reality as a Native woman and as a writer. I've had to receive and process in ways that have challenged me to greater openness. I was thrown in, battered, wrung and then spun.

I've written the following in an attempt to express and make real the tensions in my awareness:

I've been walking the prairie inhaling the breath-taking sky, rolling hills and flatlands, watching the zippered river in sweltering pulse. In Kuala Lumpur, depending on which part of the city we visited, slime smells slid down my throat. I wanted a bottle brush to bristle off the residues. I've also been walking our back alleys, marveling that our rot is in bins and will be delivered to a collective dump, not carelessly disposed of in every culvert, drain, stream and back alley where people cook and live. In our country, I can dine assured that my meal has to meet health standards, and will be inspected

if I complain.

Everywhere we went, we bartered and learned to stick to our offer. Inevitably I felt guilty wondering if "I" ripped off a zealous entrepreneur who probably needed the extra pennies more than I. Malaysia is a country of torrential rains that sweep debris into the water systems so we always bought bottled water, taking care not to suck on ice cubes in restaurants. When I returned home, I took great pleasure in allowing shower water to trickle into my half-closed mouth swallowing the sweet taste. How wonderful it is to be back to the familiar.

We are rich and fortunate here in Canada. I came back angry at my people, wanting to kick shit. And, although I understand the apathy and the demoralization, I cannot and will not accept our victimization. I realize the danger in developing a "blame-the-victim ideology." I must therefore bring myself back to that place where I started the search toward self-actualization and how difficult a journey that's been. I was brought up with the overwhelming reality that authorities dictated how I should live within a prescribed context, and to challenge that system meant I had to have "some sort of know–how." I didn't have a clue what this "know–how" was or what it meant. Whenever I dared to assert myself I was faced with humiliation, forced to recall that I was a second rate citizen, and that whoever extended a helping hand was doing me a favour, and I had better not forget it. Traumatized by family violence, the lack of stability, and as a survivor of residential school, for me the forging into a city lifestyle was as foreign as stepping onto the moon. My demons acted out accordingly. So? How can I rightfully kick shit and feel justified in doing so? I don't think I can.

We've land to hunt, to raise poultry, and plant small gardens, little things my parents did to be self-sufficient, small independent acts I saw in tiny plots along the country of Malaysia even though the poverty was stark in its telling. The fourth world – the original people which the Malays are called – the worst of the poverty-stricken, sat by the roadside, selling baskets of fruit though fruit is abundant, along with parcels of large leaves they collected for wrapping desserts and rice. I wondered if welfare was an available option. Not far, their homes made of tin and thin walls of wood stand on stilts; tree branches covered with flowers bend their graceful necks to provide shade; roosters, chickens and their broods peck about; garbage spews. These small acts of self-assertion matched what I've witnessed at home. I must recognize in my ranting that many women spend hours beading, filling contracts for large industries, baking bannock to sell for their next meal or to pay for the next bingo.

This week my Elders visited me. I listened to their pain as they described "WILLY Day" where ninety-five percent of the reserve families wait in line to receive their welfare cheques. I listened to various relatives talk about school dictatorship, if they dare to challenge or complain about their lack of holiday pay or want protection from intrusive explosive parents, their jobs would be on the line. I heard about the embez-

zlement of reserve funds and those who line their pockets, how band councillors don't support and attend community functions, how nepotism ensures jobs and home repairs while other homes turn into out-houses. I heard about how the elderly who require home visits cannot expect more than a table wipe and how they're forced to pay for wild game. I heard their helpless outrage.

Where is the site for surgery? What medicines are needed? What has happened to our values, our morals, our sense of community ethics? Where do we ignite self-determination? How do we plant the germ of faith? The hope? The will? What can I do? Recently a friend said to me, "So long as hope exists we are rich. If we lose that we are truly impoverished."

My writing is not perceived as social action, the issues I address explore festering sores. I am accused of promoting stereotypes. Bleeding the wounds, how can this be healing? I'm asked. Aren't looking and excavating the pus a beginning? I know that in writing these things I am feeling the guilt of my own comfort, the luxury I have to reflect and to write, who after all has this privilege? Still I have to reassure myself. My husband and I have sweated to ensure this life for me and my children. We've taught them to be self-governing. Last night our Elder said you're lucky your children take your grandchildren home. Many dump their kids on their parents. And that makes me sad. I've taken on and confronted my demons in therapy, returned to my Elders, and to Vision. These things which were eroded from "under the feet" of my parents and of myself I've repaired.

But this is just a fraction of the story.

I've allowed myself to be marginalized in various situations and acted as a token Indian because I wanted to ensure a Native voice and presence was in place. I was the third possibility for this trip and I graciously accepted the invitation. I was told by more than one person before I left for Kuala Lumpur "I should be grateful for this opportunity to travel and have my work exposed and I should just learn to accept that I'll probably be Pocahontas forever." I wondered just how seriously my writing was taken and I failed to appreciate the romance. I was asked to sing a song and bring my custom. Sure I could sing a song, I had one song that appeared in both my books and this would be an honour. And costume, well I really didn't have one other than a buckskin dress designed by Daisy deBolt. If these were part of the deal I suppose I could lay aside my pride and go along with these expectations. Tokenism, ah well, it was just one of those things I told myself. I wondered if my absent counterparts would have succumbed to wearing their warpaint and bustles, to drumming and chanting their songs? But who are you to complain I am told, you're a privileged woman.

If I am to talk about how this Malaysian trip has enriched my writing career,

then I must address all the issues I faced, truthfully not only for myself but I must share this with others too. For we must squirm in order to grow.

Louise Bernice Halfe

Louise Bernice Halfe, also known as Sky Dancer, was raised on Saddle Lake Indian Reserve and attended Blue Quills Residential School, and now resides in Saskatchewan. Louise's first book of poetry, *Bear Bones and Feathers,* won the Milton Acorn Award for 1996, and was shortlisted for the Spirit of Saskatchewan Award, the Pat Lowther First Book Award, and the Gerald Lampert Award. Her second book, *Blue Marrow,* was recently published by McClelland & Steward. Louise's work has also appeared in various anthologies and magazines, notably *NeWest Review*. She has been on "Morningside," "The Arts Tonight" and "Ambience."

Gifts From the Trapline

October is my favourite month. Has been my favourite month for as long as I can remember. I guess because for me, it's the most beautiful, most colourful month. It's the time when the Creator turns the bush alive with all the colours of a huge bonfire. Then, slowly, as the month progresses, the brightness of the colours of the leaves on fire sub- sides and fades, and the leaves now brown, fall slowly to the ground to become a soft blanket, covering Mother Earth, keeping her warm, feeding her, nurturing her. At the same time these leaves, now devoid of their bright colours become shelters for many creatures large and small, providing them with warmth over the long cold months to come.

Here in North Bay, Ontario, as the month of October progresses you can feel the nights getting much colder. You wake to mornings where you can see your breath in the air as you step outside until the sun takes the chill out of that fall air. October is home for me.

This time of year is exciting for a lot of us outdoors people. Being in the bush just feels right. There is nothing like one of those October days that starts out crisp and then the sun warms everything up and jeans and a t-shirt or sweatshirt are all you need to wear. These kinds of days are great for a hike into the bush, a picnic, a quiet canoe trip on an area lake.

October is special for me now for another, more important reason. On October 22, 1996 I was given the most precious gift a woman can ever receive. But before I go further, let me take you back and share a little family history with you.

Back in 1961, my daughter's paternal great grandfather Sam Cote, had one of the last dog teams in the Temagami area. He and his wife, Bessie along with their kids had always spent a great deal of time in the bush. For them, October meant trapping sea- son began in earnest. It also meant a lot of fresh meat for the family: deer, moose, beaver, muskrat, partridge, rabbit and whatever else could be added to the food cache.

December of that same year found my daughter's grandmother, Edith, in labour at the family trap camp deep in the Temagami bush. Her father Sam, hitched up the dogs and took her to the nearest neighbour to call for help. He then continued on, taking his daughter in labour by dog team to the main road where help was the local police officer, who took my daughter's grandmother the rest of the way into town, in his cruiser, to the hospital where my daughter's father was born.

It's funny how the Creator brings us full circle sometimes. Thirty-five years later, on October 22nd, on another trapline, in another little trap camp made up of just a one-room makeshift cabin with no running water or electricity and just a bucket to pee in – unless you wanted to walk across the clearing to the outhouse – we, my daughter's

father and I, had been setting up our trap camp for the past week or so. On this particular day we had come into camp early in the morning and had spent the day setting dirt hole sets and snares for fox. We had also left a few cubbie sets for mink and muskrat along several creeks.

It had been a long, tiring, busy day. But we couldn't have asked for a nicer one, it had been warm and sunny all day. We'd had dinner and dusk had turned into evening. Night comes early in the bush with no city lights to hold it at bay. The fire in the wood stove was burning nicely, warming up the cabin. We were standing outside enjoying the quiet of two hundred square miles, knowing that we were the only ones there.

It was one of those October nights where you don't need a coat, just an extra sweatshirt. As we stood there listening to the quiet and enjoying the calming feeling of the bush around us we could feel the land slowing down, preparing for winter. We looked up into the sky. And there above us, seemingly for us alone were Waasnoday, Wawatay, the Northern Lights.

Neither of us had ever seen a sky like that before in our lives. We watched as Waasnoday filled the sky. We were watching the same place in the sky when a magnificent shooting star shot over our heads, and seemingly dropped into the trees. Lindsay, my daughter's father, made us each a cup of tea and we sat back in our lawn chairs side by side in our little clearing in the bush, just touching while Waasnoday danced above our heads.

Now, here's a curious thing. I had heard stories of how you can hear the Northern Lights if you are lucky enough. Well, I can tell you, that night, up there on the trapline in the quiet of the bush we heard those lights singing. They danced above us, filling the whole sky with their mysterious, white light. And you know, not only could we hear and see them, but we could feel them too. The energy coming from them lifted the hair along my arms and filled my spirit with an energy I've never felt before, a vibrant happiness and a deep longing at the same time. I knew through my whole being that that night was special, that we were being given a gift that would change our lives.

As we sat in those lawn chairs straining our necks to look up overhead, drinking our tea and holding hands, we shared an unspoken appreciation for all that surrounded us at the moment in time. And as my spirit soared, joining in the dance and song of Wasnoday I was filled with such emotion that I realized I had tears running down my face. I said, "You know, I can't imagine a more beautiful place than right here to conceive a child." I don't know what made me say that. The teachings remind us to be careful of what we ask for and in the asking itself.

After more than an hour, our tea gone and, with sore necks, we reluctantly decided to go to bed. Morning, after all, comes early when you have to be up at dawn to check sets and snares. We took our last look at Waasnoday as they continued to dance and sing above us, seemingly just for us. And as we climbed into a bed that consisted of

a piece of foam barely a single bed wide in our cozy trap cabin I knew that the Northern Lights were still dancing above us. And even though I couldn't see them I looked up over Lindsay's shoulder as we lay in our intimate embrace looking through that makeshift ceiling that was only a few feet above us and I danced with Waasnoday knowing at that moment that they and the Creator had bestowed upon us a gift, the most precious of gifts.

Almost immediately, in an innate way I knew without a doubt that the gift we were given out there in the trap camp was real. I knew that I was pregnant. The doctor confirmed this three weeks later. Now, here's the circle that I referred to earlier – Lindsay was nearly born on his family's trapline and nearly four decades later our daughter was conceived on a trapline, not the same trapline, but a trapline just the same. This circle binds our family, even though Sam and Bessie and my daughter's grandmother Edith are no longer with us. We are still in touch with the land and the spirits of the land, sky and water, and the Creator recognized this and brought us through Waasnoday our most special gift, our daughter Shaiyena. At that same moment the spirits of Sam, Bessie and Edith were smiling down on us, watching, knowing that their son and grandson were continuing to use the skills taught to him by his mother and grandparents.

And we have already instilled the love of the trapline in our daughter. Last October with our daughter in a Snuggly, we packed lunches and spent days setting and checking traps. I breast-fed her, changed her and carried her close to me – she slept as Lindsay and I set and checked traps and snares.

Her second October, 1998, finds her outside where she loves the wind in her hair and you can see that she sees and feels the spirits of the land, sky and water. Our daughter embodies at least five generations of people who have maintained a connection to this land and its inhabitants. It's in her blood and it's where her spirit came from and will surely return to.

My mother is also connected to this story. October is the month of my mother's birthday. And I have always associated October with my mother and all the comfort I found in her. I associate the month of October with "ojiiwin" or motherhood now more than ever, because that is when my own time of ojiiwin began, on the 22nd of October 1996. Now, everyday as I watch my daughter grow and discover her world, I am reminded that I have also come home.

Abby Cote

Abby Cote lives with her partner Lindsay and their daughter, Shaiyena in North Bay, Ontario. Growing up in the northern-most suburb of Toronto, she felt her heart and

spirit were always called north. Since early 1977 she has been a freelance journalist and photographer covering primarily Native arts and entertainment. She is a regular columnist with the *Anishinabek News* published by the Union of Ontario Indians. In early 1999 she was approached by, and became a regular columnist for, the largest Native-owned independent newpaper in the United States, *News From Indian Country*. Since 1997 her work has been published in a number of newspapers and magazines from British Columbia to Quebec and in the United States.

"I dedicate this story firstly to my daughter, Shaiyena and to Waasnoday who brought her to me. Shaiyena, you are the joy of my life. after all the stress, pain, fear and anxiety that I felt carrying you and giving birth to you ten weeks prematurely, all I can do is look at you and be utterly amazed that I can love somebody as much as I love you. Secondly, to my partner Lindsay of the Teme–Augama–Anishnabai, and to our families. After all, it is through family that we gain our beliefs and values and our connection to the natural world. We are raising our daughter to be a proud Anishnabaikwe, connected to and knowing her family history."

A Memory of Childhood

"Where do you live?" asks the blue-eyed girl.

And me with my dark eyes look at her and point across the river.

"Over there, close by the Mountain," I reply.

"Isn't that where the Indians live?" she asks.

"Yeah..." I say, "the mission, that's where we live."

I watch her wrap her golden hair around her fingers.

"How come you're on this side of the river?"

"Cause I like to follow the railroad tracks across the bridge."

I smile sheepishly and brush my dark hair off my forehead.

"Are you allowed on this side of the river?"

She has a gentleness to her voice as she speaks.

"I think so," I nod. "I like to follow the railroad tracks 'cause I wonder where they go.

When I walk, I sing songs my Grandmother taught me, and sometimes I forget how far I've come."

I shrug.

"Maybe I'm not allowed to cross the bridge over to this side."

I look around for signs that tell me I should not be there.

The blue-eyed girl looks too.

"I don't know, maybe I better go back."

The girl points at a sign behind me.

It reads...THE MISSION

 INDIAN RESERVE

"I have to go," I say.

"Hey wait." I watch her grind the toe of her shoe into the ground.

"Can I walk along the tracks and over the bridge with you?" she asks.

"Do you think I'm allowed?"

I shrug again. "I don't know." She shrugs too.

We look at each other for a long time. Then we turn to go.

And we both head off in the direction of the mission, my home.

I begin to sing. She hums.

And we walk over the bridge along the railroad tracks to my side of the river.

A Long Time Ago

A long time ago in childhood, I lay on my back
hidden by my field of tall sweetgrass and blue sky
smelling the familiar smells of summer
picked over strawberry plants, drying hay,
smoke from the fire beside Nokomis' one room shack
I already taste her bannock, though she has not yet cooked it.

The sun is hot, beating on the tar paper roof.
Strange odour that black paper holds, mixed in with the breezes of wild flowers.
Foreign, unnatural, it creates a burning in my nostrils
But it too is familiar and home.

I lay, watching black crows flying over me
from birch to poplar tree
And they call out above, their stories they tell each other
I listen carefully so that I will remember them too.

My Nokomis calls out, "You Dreamchild,"...
in a language I understood long ago
"Go play, go explore, find the world beyond your field
And beyond your old Nokomis' shack."
"Go play child."
I hear my Nokomis laugh.
The wind catches her laugh song and carries it far away.

And I go off to explore the world beyond my field of sweetgrass
Beyond my Nokomis' shack.

A long time ago my Nokomis lived in her tar paper shack
Her fire is gone and her home has fallen away
My field of sweetgrass has been built upon
And I can't find my Nokomis
But her laughter is in the wind
And the black crows call down her stories to me.
I remember my home, it was a long time ago.

Jan Bourdeau Waboose

Jan Bourdeau Waboose is Bear Clan of the Anishinabe/Ojibway from northern Ontario. She has worked with the Union of Ontario Indians for ten years. To date, she has published four children's picture books: *Where Only The Elders Go, Morning Of The Lake, Firedancers* and *Skysisters*. Her short stories and poetry have also been published in various anthologies.

The Role of a Traditional Gitksan Artist

Traditionally, in my culture the role of the artist has been to record family histories. The artist collaborated with the person who commissioned a piece, before going into retreat to develop a visual history of that person's family. The work was shown publically after it was finished, just as happens today at an art exhibition, only the artist composed songs and created performance pieces to go with the work and the chiefs were called in from the surrounding areas to witness it. Art is a holistic thing, it tells the history of the people and it is a way of communicating that history from one generation to the next.

Women play an important role in the preservation of my culture's history and traditions because we're a matrilineal culture. So, in my work as a visual artist, oral historian, writer, and public speaker I have to bring forward my family history. Most of the arts that are created by First Nations' artists are important on many different levels: they are important as objects of beauty but they are also important for their sacredness and for the history they tell. When you look at a piece you know that a family has been represented: it's like opening a book and reading, if you understand the language of that culture.

When the potlach ban was lifted in 1951, I felt that work had to be done to educate people to develop a better awareness of our art and culture: this is how I started as a teacher. And I am a historian because I go and seek out people who have the knowledge, the old knowledge, nothing that you can read in books. As to being a community organizer, we are raised to understand how to be good community organizers because the women are the ones who put on these huge feasts.

As a visual artist, I try to portray things that are important to me. When I did the portrait mask of my great grandmother, for example, I imagined how she would have looked when she was younger, when she wore a lip labret. By the time I was old enough to know what was happening, all of our customs had been banned and she could not wear her lip labret. I used to wonder why her lip hung down and then I noticed there was a hole right through it. When I asked my family about it they would say, "Oh, that's what we call lip labrets." That's all they would say. They didn't talk about the banning of our cultural traditions. When I was young that answer was satisfactory, but later on, I thought, "Why couldn't my grandmother wear a lip labret if she was a noble woman and had the right to wear a lip labret. Why was she made to stop?" So I became interested in being a political activist working for people who can't speak for themselves anymore because they are gone and for people who have been marginalized. I work for people who have somehow lost their voice because the dominant society has spoken with such force and said, "This is how it is." And I'm saying, "No, no, we have to speak up if we ever want to reclaim our identities."

We don't have a word in our language called "art" because art was all around us. If I went for a walk as a child I'd see the totems and the community hall which not only housed art but was a work of art in itself. And the storytellers were very artistic in their delivery of the stories. When my grandfather, grandmother, mom or dad spoke, I would see an image of what they were talking about. You never interrupted a storyteller when they were speaking. If there was something you didn't understand, you had to ask later. So, art was fully integrated with the daily life of my people. Artists were provided for on a life-long basis; they didn't have to go out and hunt because their work was art. They had to understand all of the different family histories and the imagery that went with these histories. Their lives were fully integrated with the larger community, they were not separate from it.

I started curating because I felt that it was important that our voices be heard. I don't go looking for work, I'm invited to consider different projects. But I still have to go for an interview and the usual question is, "well, what is your background?" So I say, I was born in Kispiox and I was delivered by a medicine woman in my great grand-mother's bedroom." I know this is not the background they are talking about but this is *my* background. We have different ways of finding what is important to us. I was born a Fireweed and nobody can take that away from me; my family crest is the two whales and that's an earned identity. Our family has to pay taxes in the feast hall to keep up that title: all of the family members have to contribute and the Chief, in particular, has to contribute large sums of money. The financial institution of the Gitxsan is very much the same as the financial institutions of the Western world except that we have much more fun paying our taxes.

When I am doing my art I really feel like I'm in a different place. It sometimes feels as though there is someone behind me who is guiding me. I just feel that presence. Once I get started I don't want to stop and sometimes I will work till three or four in the morning. And when I get up the next day I'll think, "Gee, I don't remember doing that part. Did I do that part?" It seems as though I'm being guided and that the piece just comes together. It always amazes me when this happens.

When my mother walked through the forest with me, she talked to the plants as though they were living creatures, but really she was teaching me. She talked to the little thimble berries about how pretty they were and how good they were at thickening our jam and she talked to the big broad leaf fern that we used as a placemat. This is how we were taught the names of these particular things.

When Mom taught me how to cut the salmon for smoking, she didn't say, "This is how you cut it," she just did about three and then she said, "Ok, you can do it now," and then she left. And I had the knife in my hand and I thought, "What am I going to do?" I really tried my best to remember how she had done it because our teaching is voiceless. We have to learn to watch and understand what's going on. Anyway,

mom came back out after about half an hour and I totally mangled my salmon. It looked like a filigree, there were so many holes through it. But she said, "That's pretty good" and she took a few little sticks and wove the broken meat together and said, "You can hang it in the smoke house now!" So I hung this precious piece of fish up and my mother worked away at it again with little sticks and I just stood there and watched. That's how we learn. My younger sister grasped this really well and now we learn from her. She's just like mom, she doesn't talk, she just works away and expects you to stand there and watch. When she's got everything cleaned and filleted, she'll sit on a stump just like mom used to outside of the smoke house and she'll have a cigarette. We don't ask questions, we are supposed to remember how she did it. That's the difference between the Western style of learning and the Gitxsan way of learning. The Western way is with words – a steady flow of words – which you have to retain. With us the teaching is wordless. I think its important to notice these differences because there are many different ways of learning. There isn't just one way.

Doreen Jensen

An artist, teacher, historian, curator, political and environmental activist, Doreen Jensen was born in Kispiox. A graduate of the Kitanamax School of Northwest Coast Indian Art in Hazelton, Doreen works in carving, weaving, jewellery, printmaking and button blankets. Her work as a historian and curator includes the exhibition and publication of *Robes of Power: Totem Poles on Cloth*. She is a founding member of many organizations, including the Ksan Association and the Society of Canadian Artists of Native Ancestry. In 1992 she was awarded an honorary degree of doctor of letters by the University of British Columbia. The preceeding text is part of a lengthy conversation among Doreen, Carol Williams and Lynne Bell, made possible thanks to a generous grant from the Social Sciences and Humanities Research Council of Canada.

The Many Homes of an Odawa Orphan

Before my mother Julia died, I felt I was a cherished child. There is one particular picture of my father, Stanley, that my mother captured on her mail order camera. She took some good shots.

I see my grandparents, Peter and Agnes Eshkibok's farm where I was raised. I see the pear, apple, plum and maple bush. I see many trees. The many farm animals: chickens, pigs, cows and horses. The farm machinery.

I see the crows and ravens of this vast land yapping up a storm. I hear the frog and cricket quartet, and the acres and acres of freedom. Yes, writing about it makes me miss the land. Today, I am not the keeper of the land. The people who live there are taking very good care of it. My father and I are welcome on the land whenever we want. It's usually to go pick pears. In fact, I think it's the only pear tree in Wiki. Well, the only one I've seen anyway. Farming is a very demanding lifestyle. Because my mother had a stroke we moved around on the Rez, until one home was especially made for my mother's wheelchair.

I felt welcomed into a beautiful home/world. Unfortunately my mother died, and I became a motherless child. Dad was going through his own depression and the trauma of being blamed for my mother's death. I was sent to a foster home on the other side of the Island. Uncle Bob and Auntie Josephine decided to take in foster children, and so they brought me back to live with them. Then, I went to live with grandma and grandpa in my parents' village until my dad came home from jail. My grandma Agnes would try to teach me about women's responsibilities, and grandpa Peter taught me about music. When he played his violin I was usually dancing. We cheered each other up. After my grandparents died, Dad was even more depressed. I know it sounds sad, but we both agreed that he gave me my basic needs and that's the best that he could offer.

Here's my saving grace. I had many homes, many brothers, many sisters, many aunts and many uncles. My home became my neighbourhood. My mother became my friends' mothers. My mother became the women at church. My home became my community as a young woman working for intervention and prevention of alcohol abuse among young people. Years later, I became more aware that my grieving was coming to an end. I could now let my mother go. I could accept the wisdom and knowledge of my aunts and uncles in the community – especially the elders. I just hope that the foolishness my grandmother spoke to me about when I was a child doesn't get in the way. "Esna maba - Zheeng-zhenh..." "Oh, this one...such foolishness..." I used to hear my grandmother say. That's life. Yes, Zheengiss likes to come out once in a while!

I would like to give Thanks to the spirit of our communities, wherever Our

Home is...May the Values of Anishinabe Continue... Chi-Meegwetch to the people of Wikwemikong Unceded First Nations Community, especially the women for helping my dad raise me. My home now, in Toronto, is blessed with the same spirit of women's strength. For this, in the spirit of all our relations, I will always be grateful.

Gloria May Eshkibok

Gloria is Odawa from Wikwemkong Unceded Territory on Manitoulin Island. She has worked as an actor in numerous plays across this country since 1984.

"After working fifteen years in theatre alongside our inspiring playwrights, I decided to create my own words. I am currently creating an autobiographical piece entitled *Cyclops Beauty*. I feel that this piece will help show the strength and widsom that we hold deep in our souls. I also share stories through song with The Unceded Band and The Sweetgrass City Singers. This is my way of giving back, since so many women have lifted me up to see this beautiful world which is ours."

Acknowledgments

Many people participated in the development of this anthology. Foremost, we gratefully acknowledge the women who contributed their work which made this publication possible. To the selection committee who took on a very difficult task: Rebecca Baird, Patricia Deadman, Heid Erdrich, Sandra Laronde, Lee Maracle and Maureen O'Hara; we thank you for your dedication.

On behalf of Native Women in the Arts, we acknowledge with much appreciation:

 First Peoples Words: Printed & Spoken / Canada Council for the Arts
 City of Toronto through the Toronto Arts Council
 National Aboriginal Achievement Foundation

A special thank you to designers Marilyn Mets and Peter Ledwon; and to our collaborating publisher, Barry Penhale and Jane Gibson. Others contributed their valuable skills, experience, insights, time and energy: Judith Doyle, Beth Brant, Heather Wakeling and Gail MacKay.

About Native Women in the Arts – a centre for native women artists

Established in 1993, Native Women in the Arts is an organization for Native Women from diverse nations and artistic disciplines who share the common interest of culture, art, community and the advancement of Aboriginal peoples.

Native Women in the Arts
401 Richmond St. West, Suite 363
Toronto, Ontario, Canada M5V 3A8
(416) 598–4078

About the Editors

Charmaine Peel

Lee Maracle is a member of the Stoh:lo Nation of British Columbia. She is the author of *Bobbi Lee: Indian Rebel, Sojourner's Truth & Other Stories, Sundogs, Ravensong* and *I Am Woman*. Lee is also a respected speaker and has integrated traditional Indigenous teachings with European education to create culturally appropriate processes of healing for Native peoples. She is currently the Aboriginal Healing & Wellness Coordinator and the Internal Affairs Director of the Barrie Friendship Centre in Barrie, Ontario. This past year, she taught English at the University of Toronto's Transitional Year Program and is the recipient of the "American Book Award 1999" for her participation in *First Fish, First People: Salmon Tales of the North Pacific Rim*.

Helen Tansey

Sandra Laronde hails from the Teme-Augama-Anishnabe ("the deep water people") in Temagami, Ontario. She is an actor, writer, founder of Native Women in the Arts and co-artistic director at Native Earth Performing Arts in Toronto. Sandra is published in *Cultures in Transition, Gatherings, Aboriginal Voices, Chinook Winds*, written for CBC Radio's "Outfront: new voices, new visions" and is currently a playwright-in-residence at Nightwood Theatre. Sandra is also the managing editor of *Sweetgrass Grows All Around Her* and *in a vast dreaming*. She graduated from the University of Toronto with a Bachelor of Arts (Honours), and studied overseas for one year at the University of Granada in Spain.